The Complete Airbrush Course

The Complete Airbrush Course

Roger Gorringe and Ted Gould

VNR VAN NOSTRAND REINHOLD
New York

First published in Great Britain by Trefoil Publications Ltd

Cover design by Ted Gould and executed by Roger Gorringe

Origination of illustrations by DataBase Resources, Singapore
Typeset in Century by Wandsworth Typesetting, London
Printed and bound by Graphicom Srl, Italy

U.S. edition published in 1989 by
Van Nostrand Reinhold Company Inc
115 Fifth Avenue
New York, New York 10003

Van Nostrand Reinhold Company Limited
Molly Millars Lane
Wokingham, Berkshire RG11 2PY,
England

Van Nostrand Reinhold
480 La Trobe Street
Melbourne, Victoria 300,
Australia

Macmillan of Canada
Division of Canada Publishing Corporation
164 Commander Boulevard
Agincourt, Ontario M1S 3C7,
Canada

Contents

Introduction

When we were first approached with the idea of writing a book on the airbrush, Roger Gorringe and I both reacted in the same way — 'not another glossy volume stuffed full of exotic reproduction!!' The art bookshelves seemed to us to be overflowing with colourful editions on the subject, and we couldn't see the sense in adding to the pile. The publisher pointed out, however, that to his knowledge no one had produced a single volume which contained *all* that the student needed to know about airbrushing. That was what he wanted, nothing less would do. We considered the proposition for a while and we decided that what was needed was an airbrush course. In fact we decided to adapt our existing course for art college students, expand it and produce it in book form.

The airbrush is probably the most used piece of equipment amongst graphic artists. Every studio has one and it is used on a whole range of different types of work. Some studios specialise in airbrushing. They produce those incredible illustrations of cars, cut-away drawings of engines and glamorous girlie posters. The airbrush has also played an important part in recent developments in fine art and is regularly used by painters and custom car designers.

Eventually, all airbrush users develop their own particular style and methods of working. However, as with most other tools of the artist's trade, the airbrush has its own characteristics and qualities, which must be fully understood before anyone can begin to achieve real skill in the art. The major part of this book is devoted to a series of projects and exercises designed for aspiring students, whether they be college undergraduate, experienced professional artist wanting to extend his range of skills, or simply a keen amateur.

We have already said that this book is, in fact, an airbrush course. The beginner student should use it in this manner, working through all the exercises in turn (in the way that it might be taught in an art college). Alternatively, the professional artist can select certain projects and exercises to expand his range of expertise.

Section 1 deals with the equipment and materials available to the student. Of course, it is not necessary to spend large sums of money at the outset and many of the items described are for your information only. It is very important, however, to obtain the right basic equipment, otherwise it will not be possible to follow and master the basic techniques described in Secton 2 or the more complex projects which have been set later on.

Just as we all have to learn to walk before we can run, so it is metaphorically speaking with the airbrush! Before even the simplest project can be tackled is is essential to understand the way the airbrush itself works: how to hold it correctly, how to obtain the correct mix of air and paint, learning the techniques necessary to obtain a fine line or a broad spray, what to do if your airbrush does not function properly and how to maintain it so that it does.

The first stage in the course, therefore, is to introduce the student to the airbrush, followed by the media and materials that are available. Like any other tool, the airbrush has been developed for specific applications and although these are quite numerous, it does have its limitations. It is particularly suited to work involving very realistic illustration. We have all seen reproductions on books and magazines which bring a gasp of disbelief when we realise that we are not looking at a photograph but an illustration produced by an expert airbrush practitioner. In fact the largest single use for the airbrush is in the area of photographic retouching. Most of the colour photographs appearing in advertisements in the large-circulation magazines have been re-

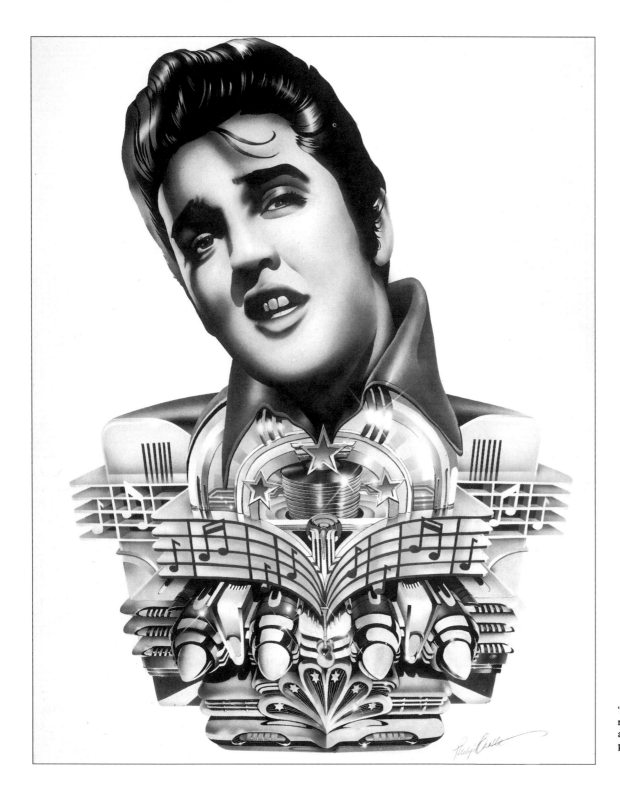

'Elvis Jukebox' 1971 by renowned British airbrush artist Philip Castle. (by kind permission of the artist)

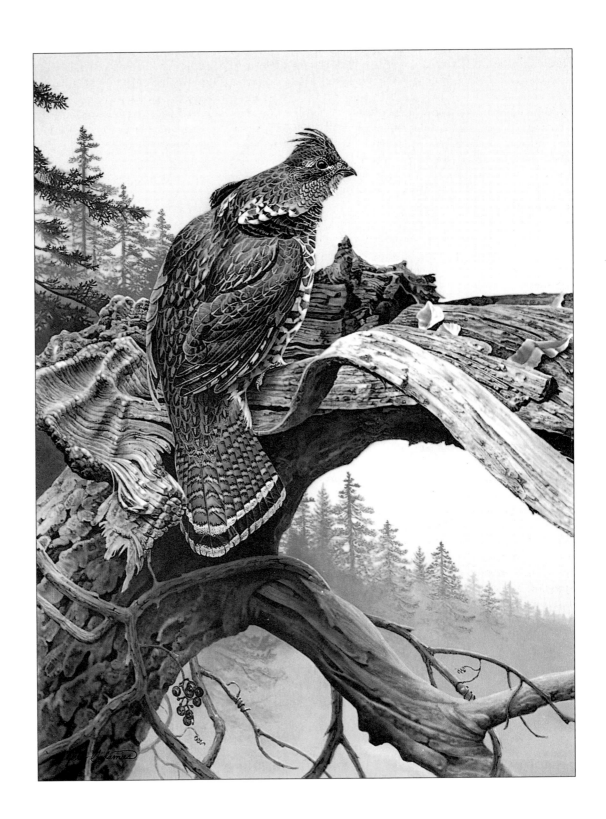

'Misty Morning Ruff', acrylic freehand airbrush painting by Jerry Gadamus, Wisconsin, USA. (by kind permission of the artist)

touched, some of them to the point of being completely redrawn. It is very unlikely that the average reader is aware of this, because the work has been done so skilfully.

The main characteristic of the airbrush is that it provides the user with the facility to produce very fine continuous graduation of tone, hence the 'photographic' appearance of many illustrations. These are several advantages over photography for the creative artist. The airbrush enables the picture to be designed down to the last detail. The composition can be adjusted precisely as required. Colour can be rendered just as the artist wants it. Images may be combined to produce a 'surrealist' or super realist effect as in much of current representational painting.

In commercial art, apart from retouching, a major use for the airbrush is in technical or scientific illustration. Highly detailed illustrations are produced from plan drawings of machinery before the machine has actually been made. Medical schools use illustration rather than photography to record the visual appearance of various parts of the human body that have bee afflicted by disease or injury.

Having grasped the various uses to which the airbrush can be put, it is vitally important that the student acquires a knowledge of the right materials that are available. An airbrush will not function properly if the inks or paints used are unsuitable, or if they are of correct type but of the wrong viscosity for smooth operation. The same applies to paper and boards. It is essential to choose the right surface to the job, otherwise it may be impossible to obtain the desired result. An embossed paper or board is unsuitable for spraying a flat colour or modelling a shape accurately. A cheap art board with a soft surface will

not permit alterations to be made and it is liable to tear or break up during re-masking.

Having equipped himself with an airbrush, the student must choose an air propellant system that he can afford. The various types and methods of obtaining a pressurised air supply are described in Section 1. One method that is *not* included is the deflating tyre! This certainly provides an air supply, but it is uncontrollable and liable to seize up the airbrush and ruin the work. Certain kinds of very coarse spraying have been achieved in this way, but it is far too hazardous to be recommended.

Finally, the student must provide himself with the ancilliary equipment, and materials necessary to work effectively. Before every stage of the course a list of items to be used is given and these should be to hand before starting, to avoid the disappointment of spoiled work.

The importance of being able to draw reasonably well is, of course, a fundamental skill for all illustrators, and readers of this book intending to follow the set course should practise their drawing whenever possible. All airbrush illustration starts with a base drawing. A weak or inaccurate drawing will invariably lead to a similar disappointing final result. For those without adequate drawing ability we have included a trace pattern, which can be used as a base drawing for each project.

Before starting on the course you should be aware of the historical development of the airbrush. The next chapter desribes the early days and the reasons for its invention.

TED GOULD

History of the Airbrush

The first known evidence of paint spraying in human history is to be found in the caves of France and Spain. Some 35,000 years ago Palaeolithic cave dwellers used hollowed out sticks or animal bones to blow pigment around the contours of their hands, a recurring image which can be seen at Lascaux, Pêche-Merle and Altamira. There were, no doubt, other individuals who discovered this technique at different times but no visible evidence of it remains.

The world had to wait until the year 1882 for the first spray-gun to be invented in the U.S. In that year Abner Peeler patented his device which he called a

Below: The earliest known use of the airbrush technique from Pêche-Merle cave, France, c.35,000 BC.

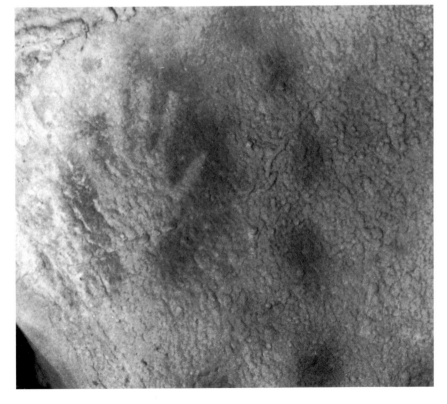

'paint distributor' and a year later the Rockford Airbrush Company was founded to manufacture and sell it.

Quite independently, as far as we know, another American, Charles Burdick, designed his 'Aerograph Airbrush', and in 1893 he moved to England and began to manfacture it under the name of 'The Fountain Brush Company'. Burdick was an inventor and water-colour artist. The story goes that he had for some time been perplexed by a technical problem he had with his painting when laying colour washes over each other. He found that the base colour was lost, or muddied when a wash was added. This he put down to the action of brushing the colour on and he concluded that a method of spraying would overcome the problem. The construction of his first Aerograph, which was of internal mix, needle and nozzle type, remains the principle of the design of most airbrushes throughout the world to this day.

Burdick's mastery of his own invention is confirmed by his excellent painting of the 'Unknown Man'. The airbrush was rapidly adopted by a number of other painters, but it was rejected by the art establishment on the grounds that the pictures were produced by a mechanical instrument and not directly by the traditional brush. Burdick himself sponsored a competition for airbrush paintings in 1900. Although a number of very good paintings were produced around this time, the airbrush was not to be accepted as a legitimate painter's tool in the fine arts for another 70 years.

If the art world had no value for the airbrush, photographers very quickly realised how useful it was for retouching purposes and this turned out to be its first commercial application. They normally had to retouch and colour-tint photographs with the brush — skilful and tricky work, but the airbrush deposits a spray of fine dots harmonizing perfectly

with photographic tones, leaving no brush marks. Photographic retouching studios mushroomed and it became the common practice for portrait photographs to be retouched and tinted. Backgrounds were reduced or eliminated altogether, wrinkles were removed and untidy hair smartened up. Sometimes the background was shaped into an oval with a misty fade-off effect known as 'vignetting'.

The development of the advertising industry in the 1920s and 30s increased the demand for airbrush retouching and commercial artists began to specialise in this field. It became virtually automatic for all photographs of products appearing in the press, in brochures or on poster hoardings to be retouched first. The motivation was the same as with the portrait photographers — to iron out the wrinkles and render the product as perfect.

Top: Early medical use of the airbrush as a throat spray.

Left: Cartoon from an early periodical.

Below: Charles Burdick, American inventor and artist. He designed the 'Aerograph Airbrush' in the late 1800s, which still acts as a model for airbrush design today.

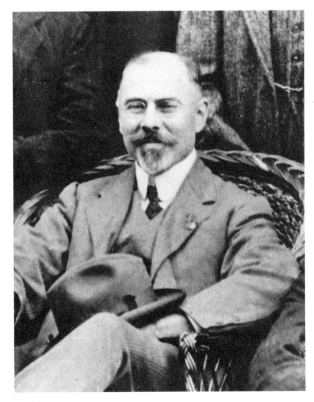

Above: Burdick's painting of the 'Unknown Man', showing his mastery of his Aerograph Aribrush.

It was during this period that illustrators and designers began to use the air brush as a creative tool. Alberto Vargas and George Petty produced many of the famous early 'pin-up' illustrations in the US. Abram Games in England gained recognition for his Guinness posters and more particularly for his poster designs during the Second World War. The techniques of mask cutting led designers to simplify the image into a kind of graduated silhouette and Games in particular was able to produce designs of remarkable clarity and impact.

Since 1945, the airbrush has been utilised in even more fields of creative activity. Textile designers spray patterns through cut stencils on to fabric, ceramicists use it for applying glazes; model makers achieve a smooth and glossy finish by the use of an airbrush, and more recently, somewhat surprisingly, fine art restorers have adopted it for the refurbishment of old master paintings. The introduction of colour photography around 1950 has added a new dimension to the retoucher's craft, making it one of the most skilled jobs in commercial art.

Advanced technology has finally produced a competitor for the airbrush — the 'paintbox computer'. These machines have been designed to produce a range of graphic effects electronically. In place of paints and brushed the user draws with a stylus on a pad on front of a screen. For retouching, photographs can be input to the computer via a rostrum video camera and then manipulated by a process known as pixelization. For the present, however, only the most expensive computers are capable of producing anything like the quality or range of the airbrush, and these are far beyond the pocket of most artists or studios — so carry on airbrushing!

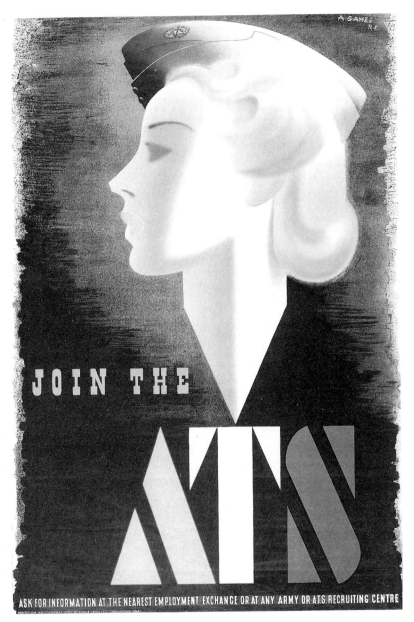

Above: World War II poster by artist/designer Abram Games. (courtesy The Imperial War Museum)

Section 1

The Airbrush

Choosing an Airbrush

This chapter is concerned with some of the various types of airbrush that are available, their particular characteristics and with an assessment of their suitability for different types of work. There is a very large number of airbrushes available today, and to include every model here would probably be more confusing than helpful to the student. We shall concentrate on a selection of models produced by the principal manufacturers. Badger and Paasche in the US, DeVilbiss in Britain and Olympus in Japan. The purpose is to enable the beginner to make an informed choice when considering a model to buy.

METHODS OF SPRAYING PAINT

Mouth diffuser This is the cheapest and probably the most unreliable way of atomizing paint. It works by air being blown by the mouth along a horizontal tube across the top of a vertical tube (which is placed in a paint container). This causes a vacuum to form in the vertical tube, drawing the paint up — this is then atomized by the horizontal air flow. Mouth diffusers can be obtained at most art suppliers. There is a version marketed as an airbrush for model makers, etc. by "Humbrol".

Spray-guns These are designed for spraying large areas of flat colour on objects like cars. They usually work on the same principle as the mouth-diffuser, but under powered air pressure. They are not suitable for fine detail work, but if your work is involved purely in the area of model-making or large-scale painting on flat colours a spray-gun may be the right choice for you. These normally have manually adjustable cams to control air and paint flow.

Aerosols These work by the paint being forced up a feed tube under compressed air pressure. The mixture of paint and air is expelled through a hole in the nozzle. Aerosols are available in a wide selection of colours, but are only suitable for the one-off job. Like

Right: DeVilbiss Super 63 – model A on the top, and model E beneath it.

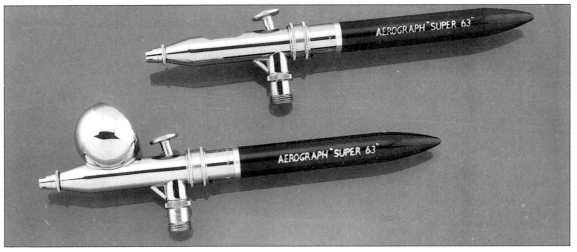

the spray gun they produce a flat spray which is uncontrollable, not suitable for fine detailing.

TYPES OF AIRBRUSH

The most important factor in determining your choice of airbrush to buy is the kind of work you will expect it to do. Generally, it can be said that the cheaper, more simple construction will only cope with work that does not involve fine detail. If you are intending to produce complex illustration, either technical or freehand, it really is necessary to obtain an airbrush which is capable of doing this, and they are at the more expensive end of the market.

Single-action external mix The basic airbrush design is identical to the spray-gun. Like the mouth diffuser it sprays a stream of air under pressure over the top of a tube connected to a jar of diluted paint. It is worked by a single-action lever; it has no needle or nozzle, and the volume of air and paint has to be adjusted manually.

Single-action internal mix needle-operated This type of airbrush is recommended for the beginner illustrator who wants to master the skills necessary for the creation of detailed illustration work. 'Single-action' means that the lever operates in one direction only — downwards. When it is depressed a regulated amount of fluid will be sprayed. To increase or reduce the fluid, the needle must first be adjusted (see diagram). The 'single-action' lever controls the airflow only. This means that the operator has to stop spraying each time a change in the volume of fluid is required. In general, the internal mix system produces a more even and reliable spray.

Double-action internal mix needle-operated Burdick's earliest design was for an airbrush that included a double-action lever. This controls both the fluid and air flows, so that the operator can vary the spray without having to stop and make adjustments to the needle. It is pressed downwards to open the air valve and pulled back to release the fluid (see diagram). This is the type of airbrush that most prof-

essional illustrators use, although it requires a little more skill on the part of the operator than does the single-action type. The majority of airbrushes manufactured at present are of this design and there is a wide selection of models on the market from which to choose.

The Turbo The Paasche AB airbrush has a most unusual design. It is operated by an air-driven turbine with controlled speeds of up to 20,000 rpm. It has a double-action lever and can achieve spray patterns ranging from a fine hairline to a width of 3″ to 4″ at a distance of 5″. The Paasche AB is the only one of its kind on the market.

Suction-feed or gravity-feed These terms refer to the method by which fluid is fed to the airbrush. It is always by one or the other method. Suction-feed (Bernoulli's principle) is based on the phenomenon of air pressure forcing the paint up from a jar below (as in the case of the mouth diffuser). It is pulled into the air-stream and atomized. Gravity-feed is from a container mounted above or to the side of the airflow and the paint simply falls into the airbrush. An advantage of suction-feed is that the paint jar can be changed for another colour before it is empty. With a gravity-feed airbrush (unless fitted with a detachable colour cup) the container must be emptied before a different colour is used. However, gravity-feed airbrushes are generally better balanced when in use.

Spray-gun external mix

Single-action internal mix

Double-action internal mix

Below: An early airbrush, similar to Burdick's first design.

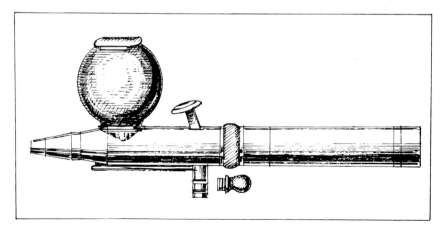

Product Guide: Airbrushes

1. Badger 250
Single-action external mix spray gun. It has an adjustable spray pattern (18.9–50.9mm). Will take medium to heavy viscosity materials. Designed for hobbyists and workshops, not suitable for detail work.

2. Aerograph Imp
Single-action external mix needleless design with adjustable fluid nozzle. Spray pattern adjustable from 5–25mm. Will spray low to heavy viscosity materials. Designed for modelmakers, hobbyists, not suitable for detail work.

3. Paasche 62 Sprayer
Single-action internal mix airbrush/spray gun. Operates on low air pressure. Two versions for low and medium viscosity materials. Both supplied with 3oz bottle. Designed for ceramists, furniture and vehicle painters, hobbyists, not suitable for detail work.

4. Paasche HAPK
Hobby and auto paint kit, also suitable for ceramists. Contents: sprayer, hose, flow pencil H 3L airbrush, 'Airbrush lessons' booklet and parts sheets.

5. Paasche SSTK
Stripe and spray touch-up kit. Desgined for general light painting, murals, vehicle customising and touch-up jobs. Contents: flow pencil H 3L airbrush, bottle assembly and air hose, thumb action spray gun, syphon jar, 'Airbrush lessons' booklet and parts sheets.

6. Badger 350-2 set
A basic set for the student or hobbyist. Contents: 350 medium tip airbrush with paint jar, air hose, jar with cover, propellant regulator wrench and instruction booklet.

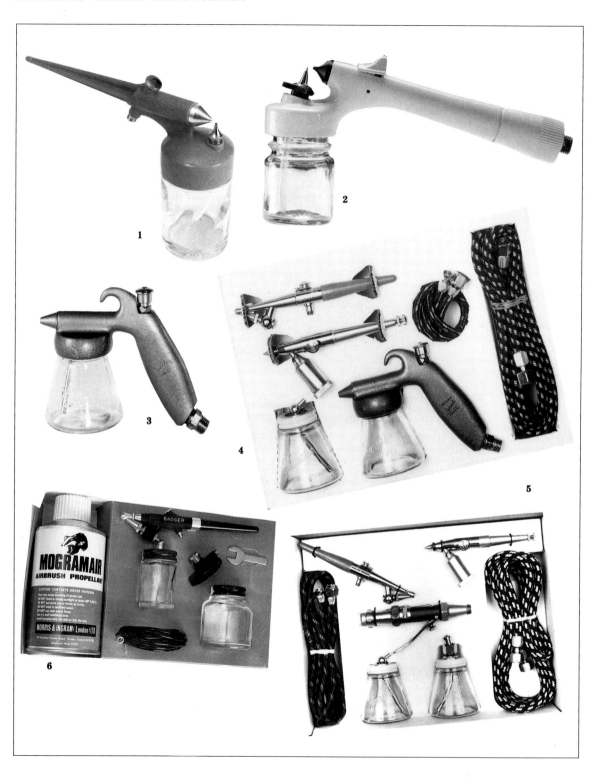

18

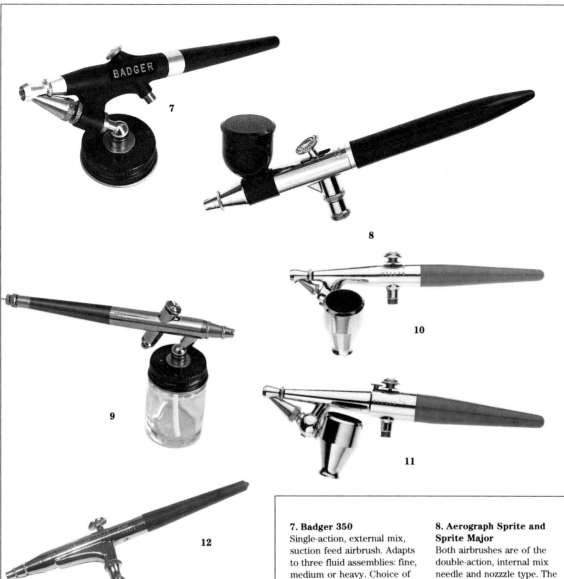

9. Badger 200
Single-action, internal mix, auction feed airbrush. Fluid volume changed by means of screw adjustment. Sprays low to high viscosity materials. Adapts to three different head assemblies. Extra fine, medium and heavy. Choice of three reservoirs, two sizes of paint jars and one colour cup. Designed for students, hobbyists, vehicle painters, taxidermists and general art work, not suitable for fine detail work.

10. Paasche F 1
Single-action, external mix, side feed airbrush. Will spray light viscosity materials only. Components include: metal colour cup, colour bottle assembly, wrench, hanger and booklet. Designed for any hobby use and adaptable for professional use.

11. Paasche H series
Single-action, external mix, side feed airbrushes. Three sizes available producing different spray patterns. H 1 small pattern, H 2 medium pattern, H 3 broad pattern, spraying respectively low viscosity, medium viscosity and high viscosity materials. Components include: colour cup, bottle assembly, hanger, wrench, and booklet. Designed for any hobby use and adaptable for professional use.

12. Olympus HP 100 series
Double-action, internal mix gravity feed airbrushes. Inbuilt 'spatter' facility. All metal construction. The HP 100A and 100B are suitable for detail work. The HP 100C has a broad nozzle for narrow and broad spray. Designed for students, hobbyists and general illustrators.

7. Badger 350
Single-action, external mix, suction feed airbrush. Adapts to three fluid assemblies: fine, medium or heavy. Choice of three reservoirs (two sizes of paint jars and one colour cup). Will spray low to high viscosity materials. Designed for students, hobbyists, ceramists, vehicle painters, crafts persons, not suitable for detail work.

8. Aerograph Sprite and Sprite Major
Both airbrushes are of the double-action, internal mix needle and nozzzle type. The Sprite is gravity fed with a low flow nozzle. The Sprite Major is suction fed from a glass container. Suitable for large area coverage. Alternative low flow nozzle, needle and air cap are available as accessories which provide an identical output to the Sprite. Both models designed for illustrators, photo-retouchers, hobbyists, students etc.

13. Olympus SP series

Double-action, internal mix, gravity feed airbrushes. A special feature is a Vernier scale adjuster incorporated in the handle for precise colour flow control. The SPA and SPB are suitable for detail work. The SPC has a broad nozzle for narrow and broad spray. Designed for the professional artist/craftsperson.

Aerograph Super 63 A and E models

Double action, internal mix, gravity feed airbrushes. Rotating cam fitted in the barrel provides a pre-set spray pattern facility. The model has a large (5cc.) colour cup for spraying wide areas. Will spray low viscosity materials. Designed for professional illustrators and all applications requiring fine detail. (see page 16)

14. Badger 150

Double-action, internal mix suction feed airbrush. It has three interchangeable head assemblies giving a choice of very fine to broad spray patterns, plus a choice of three reservoirs. For use with low to medium viscosity materials. Adjusts for LH. user. Designed for the professional artist and craftsperson.

Badger 100

Double-action, internal mix, side feed airbrush. (LH. or RH.) Sprays low viscosity materials. Designed for professional technical illustrators, photo-retouchers and anyone requiring fine detail. (not illustrated)

15. Badger 100G

Double-action, internal mix, gravity feed airbrush. Sprays low viscosity materials. Designed for professional artists doing extremely fine detail work. The model LG has a larger colour cup for broad coverage.

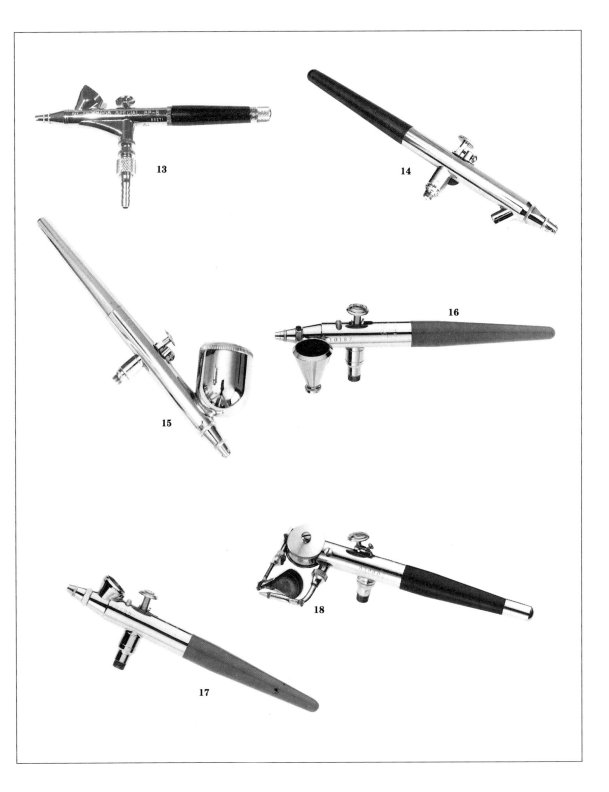

16,17. Paasche V series
Double-action internal mix
airbrushes. Gravity feed and
side feed versions with
interchangeable multiple
head assemblies for different
size spray patterns. Sprays
light viscosity materials.
Designed for the professional
artist doing detail work.

18. Paasche AB Turbo
Double-action gravity feed
airbrush. Operates by an air
driven turbine at speeds of up
to 20,000 rpm.! Adjusts from
very fine to broad spray
pattern. Sprays low viscosity
materials. Version for LH.
user. Designed for
professional artists,
illustrators, and
photo-retouchers.

Cutaway of typical airbrush (Aerograph 'Super 63')

1 Air cap guard	8 Needle locking nut
2 Air cap	9 Handle
3 Nozzle washer ('O' ring)	10 Nozzle
4 Lever assembly	11 Fluid needle
5 Cam ring	12 Body
6 Cam	13 Air valve assembly
7 Needle spring	14 Diaphragm assembly

Maintenance

Airbrushes need very little maintenance if they are used with recommended mediums at the right dilutions, and with a clean air supply of the correct pressure.

Maintenance is, in the main, confined to almost clinically clean working conditions, and constant *thorough* cleaning of the instrument with clean water or solvent.

A good spray pattern is dependent on the supply of two substances — paint and air — and most problems occur when there is a failure of either supply.

Failed air supply

If you are using an electrically driven compressor and the motor fails to operate check fuses and plugs. If no obvious fault is found consult a qualified electrician unless you are sure you know what you are doing.

If the compressor is fitted with a tank, the automatic *cut in* switch may have stuck and a light tap on the pressure adjustor box may set it going. If this is the case then the unit should be serviced as soon as possible by an expert. Should the *cut out* fail, pressure could build up in the tank to a dangerous level. For this reason regular checks should be made on the safety valve, and (by the supplier/manufacturer) a check should be made of the interior of the main tank (this is a legal requirement in certain places of work and schools) for corrosion caused by failure to drain the tank regularly.

As well as regular draining of the tank, oil levels and air inlet filters should be left as a build up here causes the motor to overwork, shortening its life.

If you are using a propellant can, check that it is not empty by shaking it and hearing the liquid gas move about. Pressure may have dropped because of lowered temperature caused by spraying for too long a period without a break. If this is the case you will find condensation/ice on the outside of the can.

Rest the can or warm it *gently* between your knees! DO NOT expose it to excessive heat. A better alternative is to have on hand an extra can. Having checked or restored the air supply to the airbrush, any failure of air or paint in the gun itself is almost always caused by a build-up of paint.

Failure of paint supply

This is usually caused by the medium used being too thick or lumpy, or drying within the airbrush. Prevention is the best cure; here are some do's and don'ts:

DO —wash the airbrush regularly

DO —mix the paint in a palette, *not* the airbrush cup!

DO —mix *all* the medium to the same consistency i.e not dragging small amounts from the edge of a lump squeezed from a tube as one would when painting with a brush.

DO —Use a dropper or large size *stiffish* brush to load and clean the paint cup — the scrubbing action does no harm and coarser hairs are more easily seen should one break off in the cup.

DON'T —Use unsuitable materials or waterproof inks/paints unless you have on hand solvents that will clean away even *dried up* medium!

Should a blockage occur

Before dismantling the airbrush try soaking it for a short while in water and a little washing up liquid, if the design of the instrument allows you to do this without any risk of the water getting into the air supply. Not for too long though, as capillary action may draw the liquid up into the diaphragm even

though this is well above the water level! You could also try drawing the needle back with the air off and then dropping a small quantity of liquid into the tip, with the airbrush held upright to allow the liquid to run back towards the paint cup. Here again beware of it going to the air supply workings.

So far we have avoided dismantling the airbrush because most damage is caused by careless handling of the nozzle and needle (in the college situation we don't allow students to dismantle airbrushes or attempt any repairs).

When dismantling is necessary, do so over a flat surface, cloth if possible, and follow the makers' diagrams carefully. The needle, if it has one, should always be removed or partially removed first. The cap and nozzle (if not fixed) can be removed and bathed with a soft brush; very fine pointed brushes can be inserted with a twisting motion (illus. 1 and 2) but nothing hard should ever be used. Some makers allow soft wood to be used on some areas but with care.

When it is removed, clean the needle along its *whole length* and examine the point with a magnifier to see if it is bent or broken.

The needle should be very lightly lubricated where it passes through the trigger mechanism (most airbrushers use the natural oils from their forehead or the side of the nose!) The reason for this very light greasing is to increase the sensitivity to the resistance felt when the needle meets the nozzle. Most nozzle damage is caused by the needle being forced against the inside conical surface and splitting it.

The cap and nozzle should be replaced first (don't forget the 'O' ring if fitted), then the needle is carefully guided to position by laying it against the 2nd finger (illus. 3). If it is suspected that the needle point has touched the metal parts at all during this procedure, either examine it with the magnifier when the point shows in the paint cup, or if this is not possible (side loading type etc), remove it, check it, and start again. If in any doubt do not push it fully home against the nozzle or it could become a very expensive blob of paint that caused the problem in the first place.

Emergency repairs

Following the basic care procedures outlined above and replacing needles and nozzles from time to time, your airbrush should last a lifetime. There are however times when by accident or just bad luck, or even the acquisition of a neglected secondhand instrument, more drastic measures are needed.

Soaking the airbrush overnight in detergent up to the depth shown in illustration 4 is a good start. If the needle is bent, lay the tapered end on a piece of glass of formica and stroke it with the end of a wooden ruler towards the tip and off the end. If this doesn't help it is better to break the extreme tip of the needle right off — the airbrush won't work very well but at least it shouldn't spatter.

A badly clogged nozzle can be reamed out by

1

2

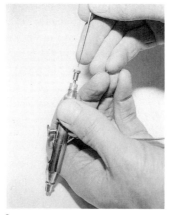

3

4

sharpening two or three 'flats' on an old spare needle. If the nozzle is not blocked completely, a small amount of toothpaste can be put on the needle tip and the needle twisted with light pressure against the nozzle until they bed together — rinse thoroughly.

There is not much that can be done with a split nozzle, but do not throw away an old one that has been discarded for other reasons. It may be useful in an emergency. We must emphasise that these extreme steps should only be taken when the parts involved are to be dumped anyway.

Hoses and supports

Most modern airbrush hoses are clear plastic, and are to be preferred to the older style cloth covered rubber, since they slide without snagging against the desk edge and can be easily wiped clean. Should water get into the air supply it can be quickly noticed before damage is done.

If propellant cans are being used, the liquid gas sometimes condenses back to liquid in loops in the hose; this also can be seen so turn off at the can, unscrew the hose and allow it to vaporise, then reconnect.

If you have an old rubber hose of the Aerograph type it is not difficult to make up a plastic one using the old connectors and ferrules (illus. 5). Purchase the required length of plastic hose 7.5mm out measure/4mm inner measure approximately. Cut the ferrule from the old rubber hose and remove the rubber completely. Then cut the plastic hose ends to a fine slant, poke the point formed through the ferrule, grip both with pliers (the ferrule can be protected with tape) and pull the plastic through until it clears the taper. Slice off flush with sharp knife. Repeat at other end. Screw the threaded connector and central core onto an airbrush to use as handle, and push the hose on with a twisting action. Warming and wetting the hose helps the whole operation.

The most convenient support for an airbrush when not in use is two cup hooks screwed into the desk edge. Arrange them so that the airbrush slopes down toward the tip slightly (illus. 6).

Fault finding

Problem	Cause and cure
Water in air supply	Drain regularly, fit water trap but don't let this lead to neglecting to drain compressor.
Intermittent spray (pulsing)	Direct type of compressor. Fit a tank if possible, or use a longer hose or two hoses joined; the pulses are lost in the extra space.
Small amount of spatter at end of stroke	Lazy spring in air cut off valve — change or adjust. Diaphragm damaged/worn — replace. Feature of some cheaper instruments if air is not continued at end of stroke — adjust methods of working. Bent needle tip — replace.
Coarse spray	Paint too thick — dilute. Not enough pressure — adjust. Pressure drop in propellant can caused by lowering of temperature — warm.
Uneven spray	Paint too thick/not enough presure. Airbrush too far from work surface.
Coarse spray on one side of pattern	Split nozzle/bent needle — replace. Minor blockage — clear.
Spitting at beginning of stroke	Paint left on needle tip from last stroke — air on first, off last.
Squirting	Paint too thin, or working too close for skill level.
Bubbling back into paint cup	Blockage in nozzle airway — dismantle and clean. Nozzle damage or 'O' ring missing — replace.

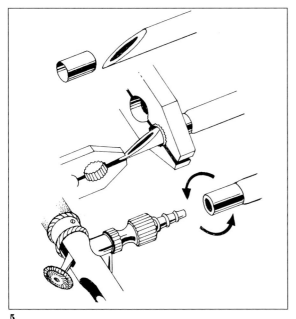

5

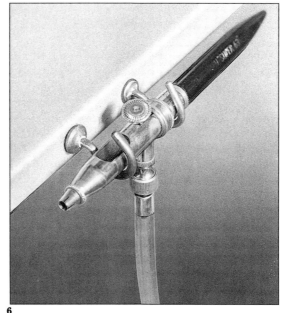

6

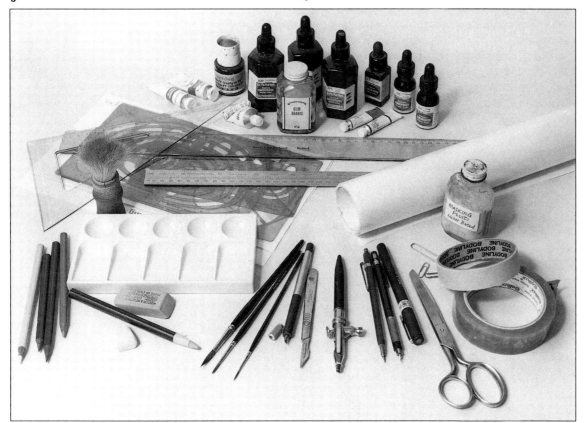

Selection of liquid
watercolours
Tubes of
gouache/watercolours
Masking film
Masking & clear tapes
Masking fluid
Gum Arabic
Black ink (not to be used in
airbrush)
Sable hair brushes
Selection of templates
Selection of coloured pencils
Several different erasers
Dusting brush
Rulers (cut only with steel
edge)
Ceramic palette (does not
attract dust)
Scalpel, swivel blade knife,
scissors, pencil, pen, tracing
point
Airbrush and air supply

Compressors and Propellants

Having equipped yourself with an airbrush it is important that you choose the right air source for your needs.

There are three types of air source generally available; the diaphragm or piston operated compressor, the compressed air cylinder and the propellant can. Most airbrush manufacturers carry a range of compressors and propellants which are designed for different studio situations and these factors should be considered before making a purchase. First, how many airbrushes or spray guns will be used? Second, will the compressor be located in a studio in close proximity to other people? Third, what type of materials will be sprayed — high viscosity, low viscosity, or both?

Cheap, basic compressors are adequate only for general work such as model spraying or ceramic glazing and not for fine detail work involving expensive airbrushes. They can be adapted for more precise work by the addition of a pressure gauge, moisture filter and reservoir. These items will cure the problems of 'pulse' and irregular air flow characteristic of the cheap compressor.

Small oil-less diaphragm compressors are usually suitable for only one airbrush unless fitted with a reservoir. They are quiet and if they are of the self-bleeding type will not overheat when running.

Recent developments in compressor design indicate that the 'pulse' problem may soon be solved, so that the small compressor will be suitable for all types of work.

Larger, reservoir compressors are suitable for the studio where a number of airbrushes will be working at the same time. They are more expensive of course, but as they normally incorporate a pressure regulator and moisture filter they are quiet and 'pulse' free. The reservoir stores the air supplied by the pump and the motor switches on automatically when the pressure falls below the pre-set psi. They are all fitted with safety valves in case the air regulator should fail and the air pressure climb dangerously high.

Compressed gas cylinders are an alternative air source, if you only use the airbrush occasionally for big jobs and you don't want to incur the expense of a large compressor. They are replaced by suppliers when empty. With this method an attachment for the air hose together with a pressure regulator must be fitted. A contents gauge is also recommended. This will show how much gas remains in the cylinder and you won't have to break off work to obtain a refill.

Propellant cans are the cheapest air source for very small jobs not requiring precision work. The pressure gradually decreases as the contents is used up and there is no way of knowing what quantity is left in the can during working.

When deciding what air source to buy it is useful to know that the average airbrush consumes approximately ½ cfm (cubic feet per minute) of air at 25 psi. (pounds per square inch). If a number of airbrushes are to be used (say 5) multiply 5 × ½ cfm to find the total cubic footage you require (2½ cfm).

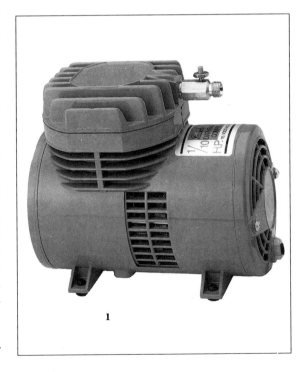

1. Badger Cyclone 1 Model 180-1
A portable oil-less diaphragm type compressor. It has internal bleed allowing use with any make of airbrush. Develops 80 cfm at 25 psi. Compact, lightweight and quiet. Can be carried from room to room. Suitable for only one airbrush.

1

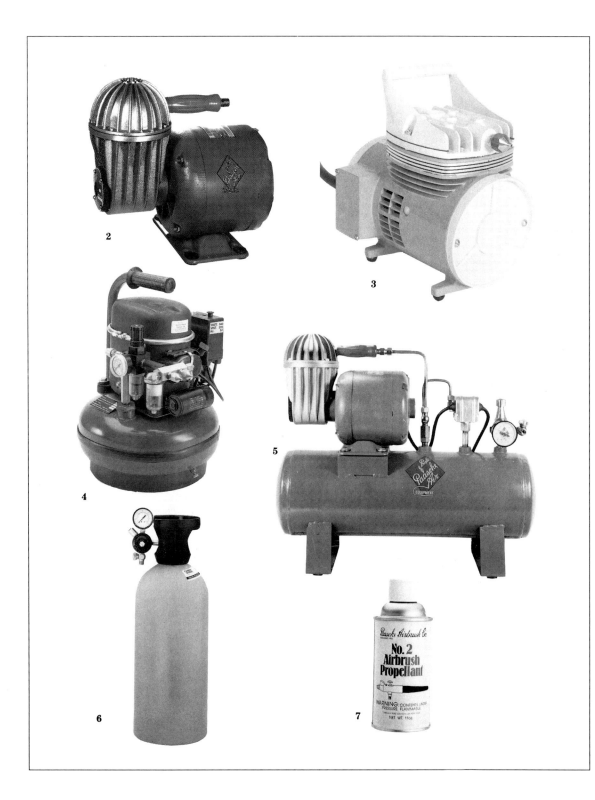

2. Paasche D 500
A portable oil-less diaphragm compressor. It is economical and quiet and suitable for all airbrushes spraying properly thinned fluids. Develops 30 psi. Suitable for only one airbrush.

3. Paasche D
A portable oil-less diaphragm compressor. It is economical and quiet and suitable for all airbrushes spraying properly thinned fluids. Develops 30 psi. Suitable for only one airbrush.

4. Badger Silent 11 Model 380-2
A portable piston-operated compressor. It has a ½ horsepower motor capable of supplying 4 to 5 airbrushes simultaneously without pulsation. Develops 100 psi maximum pressure, quiet in operation.

5. Paasche D-34 Compressor
An oil-less diaphragm compressor with large storage tank. It will supply 2 airbrushes simultaneously, but can be converted for multiple airbrush use by the addition of certain components.

6. Paasche LCT
The LCT is designed for artists who require only limited air supply and for absolute quiet, easy operation. Accurate control of carbon dioxide is provided with the air regulator. Refillable. Recommended when electricity is not available.

7. Paasche No 2 pressure tank
A replaceable unit of airbrush propellant which provides air pressure for limited usage depending on the size of airbrush and type of work. Two sizes available, 11oz. and 17oz. cylinders.

Section 2

Basic Techniques and Materials

Surfaces suitable for Airbrushing

It is only too common not to be able to choose the surface we must work on. Retouching usually has to be done on the print, and customizing on the vehicle! Even when we can choose, costs and masking methods must be taken into account.

Papers The quality of paper varies not just with its shades of whiteness and weight which are fairly obvious, but with it robustness and resistance to tearing when masks are stuck to it. The other varying feature is the smoothness of the surface and this affects the stickiness of the masks as well. Masks stick 'better' to smooth surfaces than rough (try sticky tape on glass and then on brick!) because the adhesive touches more places. The best advice is to test any surface with pressure sensitive tape because in time the masking film, which was bridging the hollows on rough paper will draw in against the surface, so try to leave the test over night if the project is likely to be a long one. Even on the best paper masking film & tape can be very difficult to remove after 3 or 4 days, so as skills increase, and working times decrease, you will find cheaper materials can be acceptable. The beginner should always use the best he or she can afford to suit the job in hand.

Cheap cartridge and printing papers OK for basic exercise: using loose masks.

Water colour paper Usually OK if masks are not on too long, but paint can creep under loose masks and the paper can cockle if it gets too wet, or hairy if rubber is used vigorously. Spraying at an angle shows up in relief!

Good quality commercial wash paper OK for most jobs but masks may not stick well enough. The surface can show if sprayed at an angle.

Good quality line paper The best if paper must be used, but remember all papers cockle when wet and are easily cut through together with the mask.

Boards Except for printing or mounting board, most are sold as art board, and have paper of various quality and type mounted on the surface. Therefore the same remarks apply as to paper, but of course they don't cockle and are less likely to be cut through.

Good quality line board is probably the best surface of all for most illustration work. No preparation is needed but some modern plastic erasers leave an invisible deposit which shows up as a lighter tone when sprayed. A light burnish with cotton wool before spraying an area that has been rubbed is recommended.

Canvas/hardboard or painted surfaces Test any masking tape or film for possible lifting of base paint, and also test for any solvennt action by the paint being sprayed.

Photographic paper Prints for retouching should be made on glossy or smooth paper, and if coloured dyes are to be used agitation in the fixer should be constant, as variation in the action of the hardener can affect take up of the dye, and a patchy result occur.

Spraying onto photographs presents few problems, the absorbent nature of the gelatin speeds initial drying, and so build up of opaque paint can be quite quick. The masking film should be cut with a *very sharp* new blade, as, if the surface is cut into at all, whole areas come away with the mask!

Some airbrush artists prefer to use photographic paper for illustration work because of its pure white colour and working characteristics, but it must be fixed, washed and dried beforehand.

PMT (Photo-mechanical transfer) paper Treat as photographic paper but with more care, as the image is on the surface & has no supercoat of gelatin. This also causes the drying time to be longer. PMT's must be washed and dried before use as the processing chemicals can prevent masking film sticking and also discolour some paints, most noticeably white gouache.

Acetate film As well as being a useful masking material, prepared acetate is a good surface to work on, and if it is taped over a photograph which is to be retouched, you can try out various effects before altering or damaging the original. For the same reason it can be laid over two images that are to be joined, the airbrush work is carried out on top completely disguising any joints. Also, if copying facilities are not available, why not try out the black and white re-touching project in this book, using acetate laid over the page?

Fibres of paper lifted by mask, showing up only after spraying

Watercolour paper shows its NOT surface when sprayed obliquely.

Masking

Masking with film

1. Correct method of laying masking film. The ruler *must* be at least as long as width of film to avoid stretching.

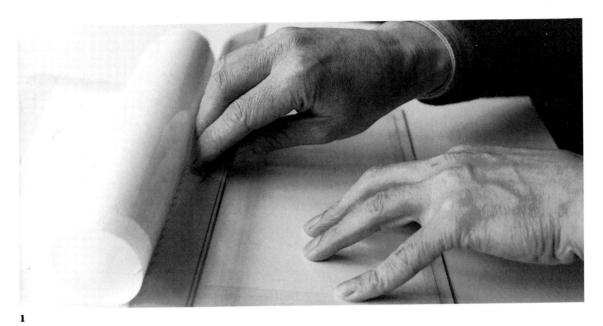

1

2. Using a swivel-bladed knife for cutting masks — good for intricate curves, not so good for making hairpin bends and for straight lines.

3. Cutting mask with scalpel — best for straight lines and essential for lifting and replacing masks.
Laying the scalpel low and holding it further up the handle to cut long smooth curves. The effect is similar to trailing a long rope: the end of the rope is not affected by hand shake since this is lost on the way to the end!

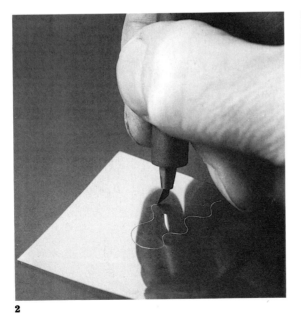

2

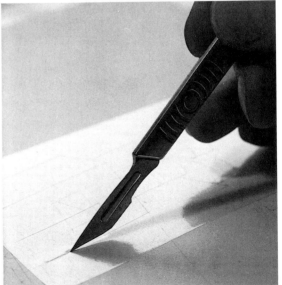

3

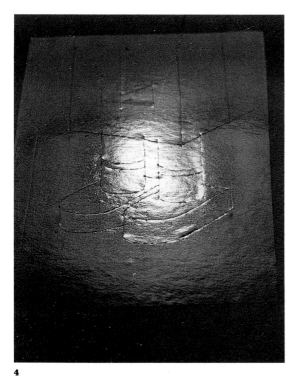

4

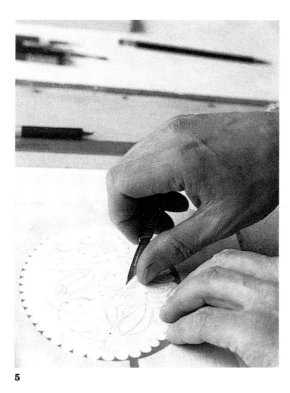

5

4. Reflecting the light on the surface of the mask to check that all lines have been cut.

5. Lifting the mask with a scalpel. Keep mask for replacing – stuck onto a backing sheet.

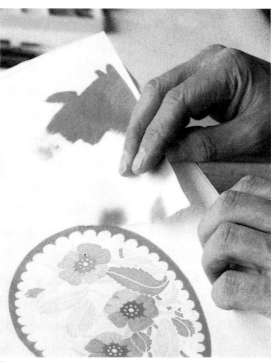

5a

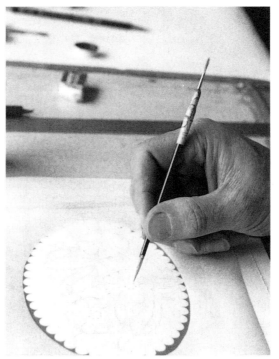

6

5a. Match a colour by spraying a sample on to scrap paper of the same or similar type as artwork. *Brushing a sample does not give the same colour as spraying!*

6. Small areas being masked with masking fluid — using the wrong end of the paintbrush. Masking fluid (latex solution) is difficult to wash out of a brush, but this can be helped considerably if, before use the brush is filled with soap and a lather is formed. This is wiped off to leave a protective residue in the base of the hairs. Masking fluid works well in a ruling pen, but care must be taken when crossing a line that has already dried, or it will be removed by the action of the pen drawing the second line.

7. Pick off masking fluid before replacing film mask, if there is any danger of the film being prevented from lying flat again.
Replacing the mask — it slides easily now that the surrounding area is dusty with overspray. With experience the pieces will slot neatly into place.

8. *Lightly* burnishing the replaced masks. Remember the overspray that allowed them to slide back also reduces the tack! Check that the edges are adhering round the next hole.

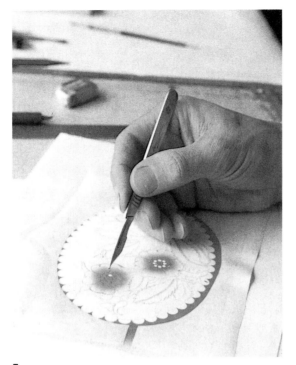

7

8

9. The moment of truth — lifting all the masks.

10. Cleaning up by hand by scraping with scalpel and dusting with shaving brush.

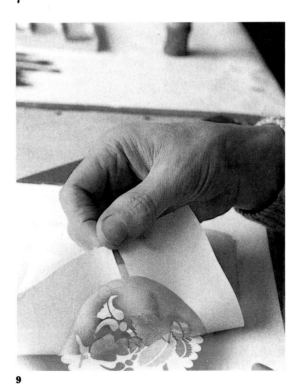

9

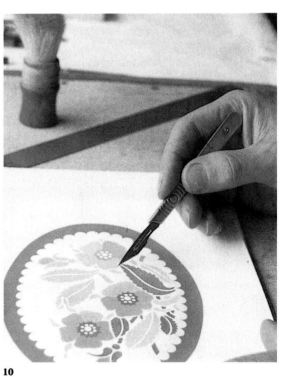

10

The Effects of Different Masking Materials

THE EFFECT

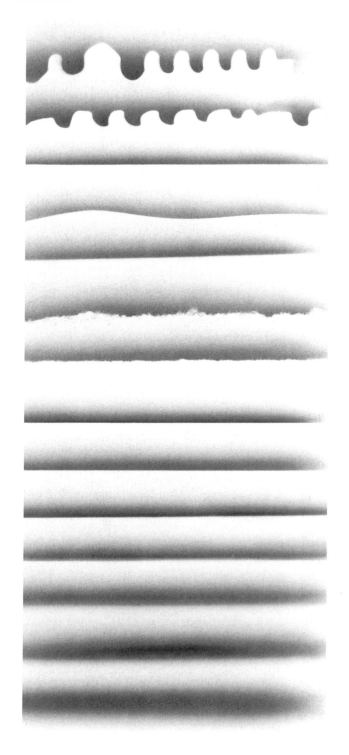

THE METHOD

Acetate torn with brush handle (see **a.**)

Acetate edge

Acetate edge, scalpel held low and trailed (see **b.**)

Folded acetate

Torn paper

Folded & torn paper

Cut Frisk film

Cut edge of paper

Folded edge of paper

Edge of card, raised slightly

Ruler raised 10mm

Barrel of technical pen

Free stroke

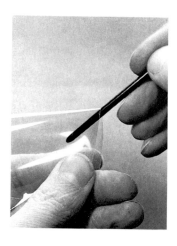

a. Nick the edge to start the tear off, then pull the brush handle upwards to produce the saw-toothed tear.

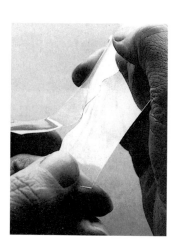

b. Scoring, bending and breaking the acetate.

Getting to know your Airbrush

Connect the airbrush to an air supply and switch on. Drop some water into the paint cup, press the finger button downwards and back, flushing the instrument through in this way at the start of each session.

The correct way to hold an airbrush is really to hold the airhose. It is a matter of personal choice whether the airhose is wrapped around the hand to stop it snagging.

Mix the paint or ink with a little gum arabic and dilute with water to the consistency of milk, drop or brush a *small amount* into the paint cup.

If the airbrush is of the type that has two movements of the control button (usually down for air, back for medium), the air must go in first, then the control, and thus the needle is drawing back until spraying starts. At the end of the spraying stroke the control must be pushed forward before the air is released, *the golden rule is, therefore, — air on first, off last!* That is at least the correct way to start. However in practice and with experience with different makes, it will be found that a modified action can be adopted that may be more convenient. For example the Aerograph Super 63 has a milled ring that allows the presetting of the needle position, and this can be inserted by hand, the control only needing to be pressed down to produce a regular spray pattern, as long as the needle is not allowed to slide forward without the air being on. If this happens the tip of the needle collects a blob of paint ready to spatter at the beginning of the next stroke — this must be blown clear away from the work before commencing.

Airbrushes with only one control movement automatically put the air on first/off last, and would seem to offer the best system. Experienced airbrush artists however like the extra control of spray pattern and grain size obtainable with the two movement type.

Spray a few bands of colour across the paper at various distances — the further away the wider the spray pattern, the closer to the paper the narrower and cleaner the pattern but it will be found a lot less easy to control.

The angle at which the airbrush is held also affects the width and quality of the spray pattern — the diagrams and photographs give an idea of what happens to the overspray and paint that bounces off the surface.

Held upright, the spray pattern is round, while at an angle the pattern is not only egg shaped but heavier closer to the hand. For this reason turning the work during progress allows you to avoid too much overspray, or use it to your advantage.

It may be that this first attempt has produced no spray at all, or a flood. Assuming a clean or possibly even new instrument, the problem is almost certainly the paint consistency.

Too thick = no spray, patchy or intermittent

Too thin = squirting, flooding.

If the paint has been diluted and the spray is still patchy, try a different colour, as some pigments are finer ground than others (compare Winsor and Newton Designers Gouache Lamp Black with Jet Black).

These are then the variables to play with: paint consistency, air and paint volume control at the airbrush, distance from the work surface. All that remains is to practice as much as possible until you can reliably produce bands of colour about 10 centimetres long of varying thickness and with no spatter at either the beginning or end of the stroke.

When this has been achieved, try some of the simple play exercises shown on the following pages, for example the moonlight scene, the feather, spraying through screens and of course writing your name.

Illustrations 1 and 2 show how the angle at which the airbrush is held affects the spray pattern.

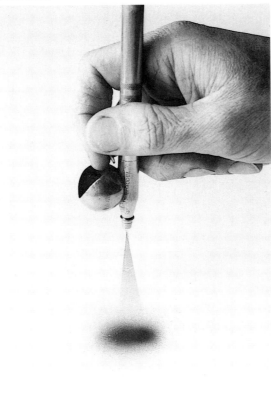

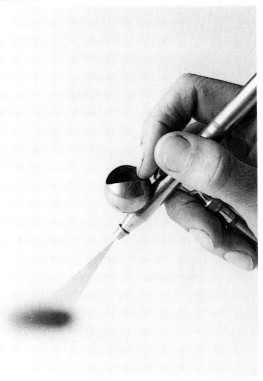

Below: The effects of different spraying distances. The top example was produced by an airbrush held too close to the work, with a result of too much air and paint. The bottom example was produced by an airbrush held too far from the work, resulting in a coarse spray pattern.

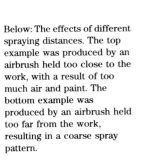

37

Playing Around

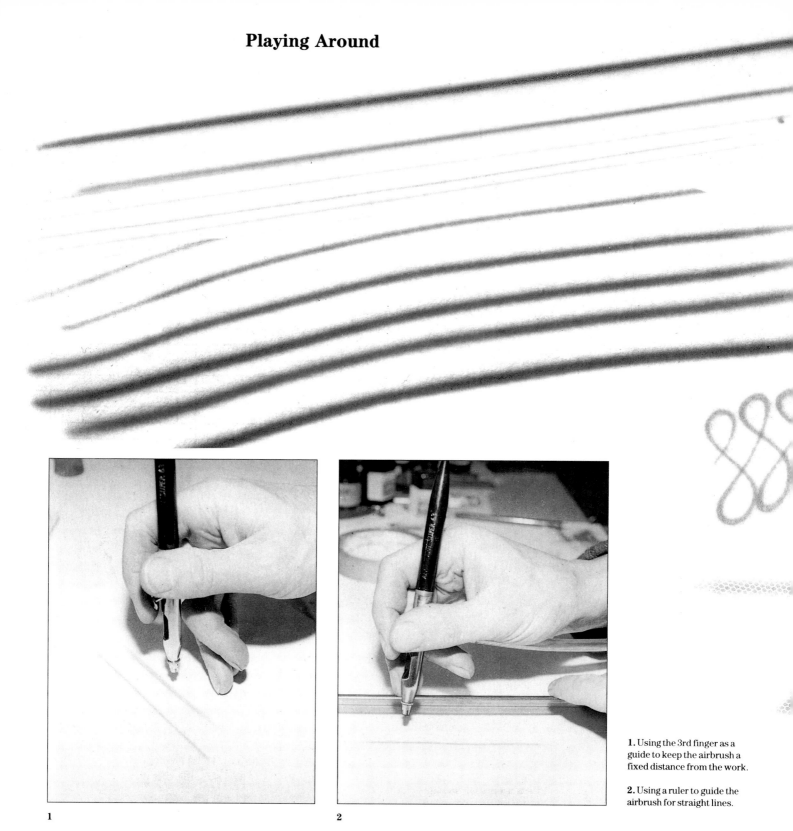

1. Using the 3rd finger as a guide to keep the airbrush a fixed distance from the work.

2. Using a ruler to guide the airbrush for straight lines.

1

2

Roger

Airbrush

Effects achieved by spraying
through net and sequin waste.

More Playing Around

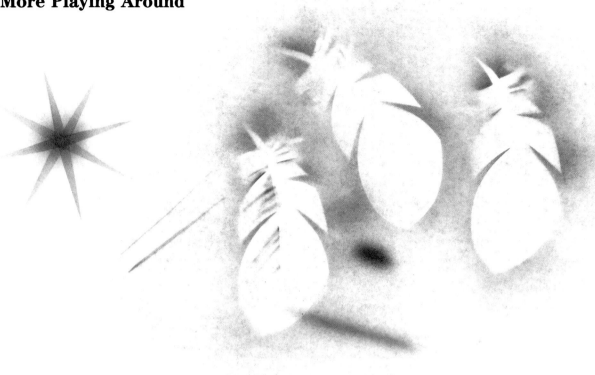

Highlights

Can add considerable sparkle to some artworks. Sometimes just a sprayed point as on the inside of the ring is enough. On the top of the ring, grey has been sprayed first to give a slight rim to the star where it falls against a light background, but it is better if the artwork can be designed so that stars fall against dark areas.

Four suggestions for producing stars – the bottom right example is the hardest to produce, being entirely free hand spraying.

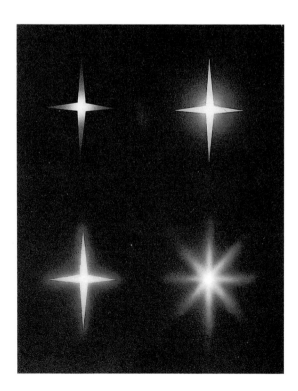

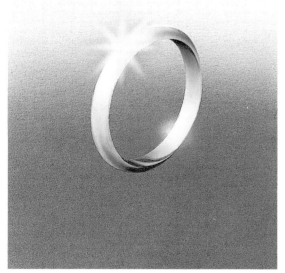

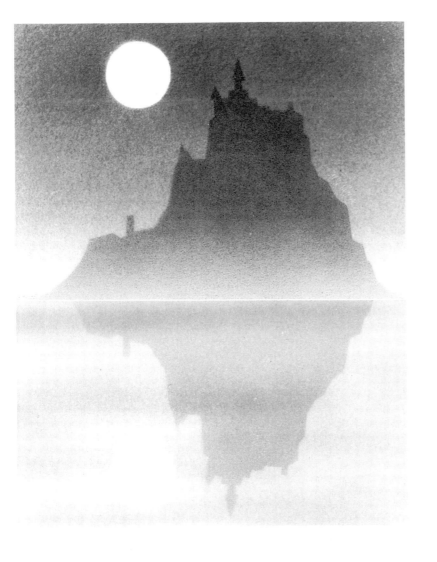

Above: A simple moonlight scene – using one paper mask that is 'flopped' to create the reflection, and a coin for the moon!

Right: Frisk film mask for outline, but sprayed through a piece of stretched gauze.

Spraying Flat Areas of Tone

Because of the circular spray pattern of the airbrush, the lovely smooth shaded effects that it produces are relatively easy to achieve. More difficult for the beginner is a flat area of less than the full strength of the paint/ink being used. An example would be a mid grey produced by lightly spraying with *Black* — so we'll try this as an exercise.

A couple of sheets of cartridge paper will do, and the black paint/gum mixture that suits you best. Lightly draw a few squares 80mm (3⅛″) wide on one of the sheets of paper, and if you like, cut a 80mm square hole in a spare piece — *not* to use as a mask but to hold over your efforts to assess them afterwards, isolated from their soft edges.

Load up the airbrush and spray lightly over the square (and over the edges) in a series of sweeps, holding the airbrush at a distance that makes each band cover approximately ⅕ of the depth of the square.

What we are aiming at is a perfectly flat 50% tint covering the whole square. To achieve this the bands of paint must overlap so that the fading off at the edges of each square cancel each other out. It sounds impossible! But with practice it is surprising how quickly the knack is acquired.

The required depth of tone is obtained by giving several thin coats. Practice will improve the aim and in time you will know exactly where the spray will land and the area it will cover.

It is obvious that one way to achieve a flat result

would be to hold the airbrush so far away that it covered the area with one sweep, but this would produce a patchy/grainy effect due to the smaller, lighter droplets failing to reach the paper. The airbrush has an optimum working distance! Spray one square this way to compare later.

When spraying a flat area, it helps to turn the work around between coats, particularly if the surface is a bit rough. This also helps with another problem — that of the adaptability of the human eye to changes in the level of reflected light reaching it.

If while spraying a flat area, you stare at a single point on the paper, any slight patchiness is evened out by the eye fooling you into thinking the job is fine, until you look away for a while and then back.

Flat area resulting from overlapping strokes.

Exercise 1: Basic Shapes

Our next exercise requires the student to render, in monochrome, some basic shapes.

These are the sphere, cube and cone. We suggest a good line board or paper is used and some low tack masking film.

Let us start with the sphere, which requires cutting a perfect circle in the masking film for which you will need a cutting compass. If you don't have one, here is a suggestion for making one. Take a pair of dividers with a spare point plus a small oil stone (a piece of fine emery cloth; or wet and dry paper stuck to a piece of card will do). Hold the dividers as shown in the photographs and stroke the spare point back and forth against the stone. You will find that the weight of the other arm will cause the dividers to rock slightly — this is fine! The two slightly rounded flats so produced will meet in a perfect tiny cutting edge.

When it comes to cutting the circle do not stick the film down on the working surface, but take a small square complete with backing sheet placing the divider point into the middle. Hold it lightly, then with the index finger of the other hand turning the masking film round a few times, you will see the film coming away from the backing paper as the cut is complete. Now peel off the part you need, stick it in place on the board, and there will be no compass point hole in the centre.

There are two basic ways of rendering a sphere according to whether the light is close to the object or far away. If it is close, the light falls as a soft highlight; if it is far away, the sphere is half light, half shadow with a soft edge, the way the planets are illuminated by the sun. There are a host of intermediate lightings, plus variations caused by the light being hard or diffuse. It is worth examining a ball in different lighting conditions, particularly the shadow cast.

The cube (page 46) is an exercise in building tones by overlaying one coat over another and removing the masks as you go.

The cone (page 47) is the most difficult by far! The band of airbrushing must taper and we know the only way to do that is by varying the working distance of the airbrush during the sweep. Our illustrations show the two wrong ways, followed by the correct rendering.

Probably the easiest way to begin with is to start the sweep ½ inch or so from the tip of the cone, working as close as you can control it, then sweep into the cone lifting the airbrush as you go. Do not try to go right to the bottom of the cone at first, but instead concentrate in getting the top third right, then making good the rest working at a more comfortable distance. On the final illustration note how a light spraying on the righthand side has held the edge but the left hand side is held with overspray.

Rendering a cylinder should present no real problems so we have included it in our first project: a little device incorporating four basic shapes in a clown figure. This is really a bit of revision but it is important not only to be able to produce a good cone, sphere, cube etc but to do so getting the overall tones matching. If this figure is not to your liking you can invent a similar exercise, but do keep it simple.

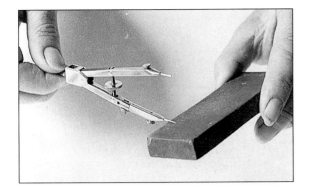

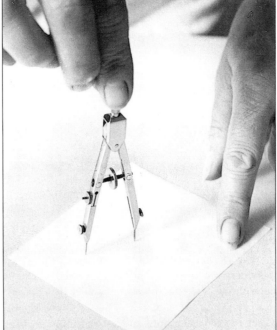

Left: Making a cutting compass from a pair of dividers.

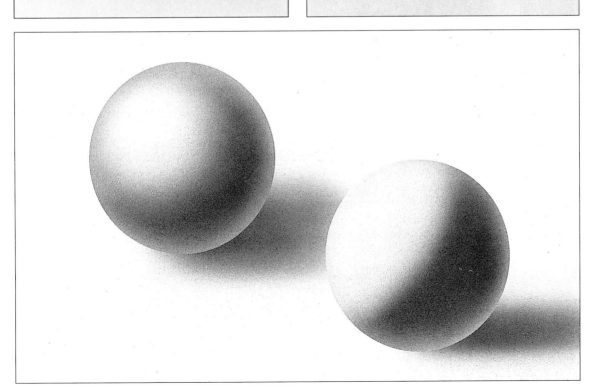

Left: Two spheres – the one on the left shows the light falling close to the object. The one on the right shows the light to be far away.

The cube: an exercise in building tones by overlaying one coat over another and removing the masks as you go.

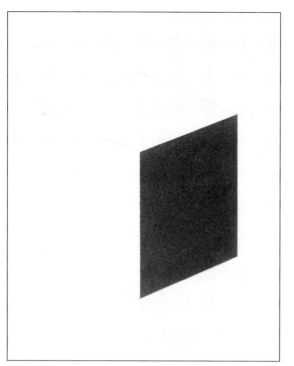

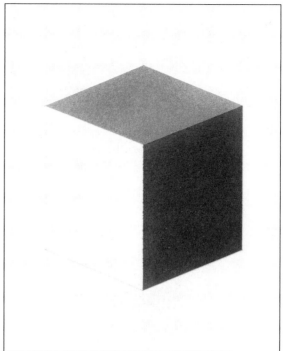

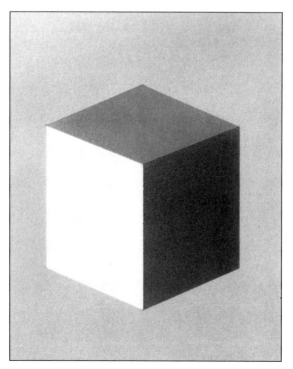

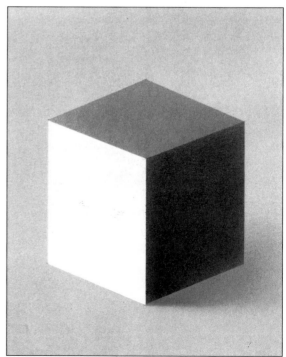

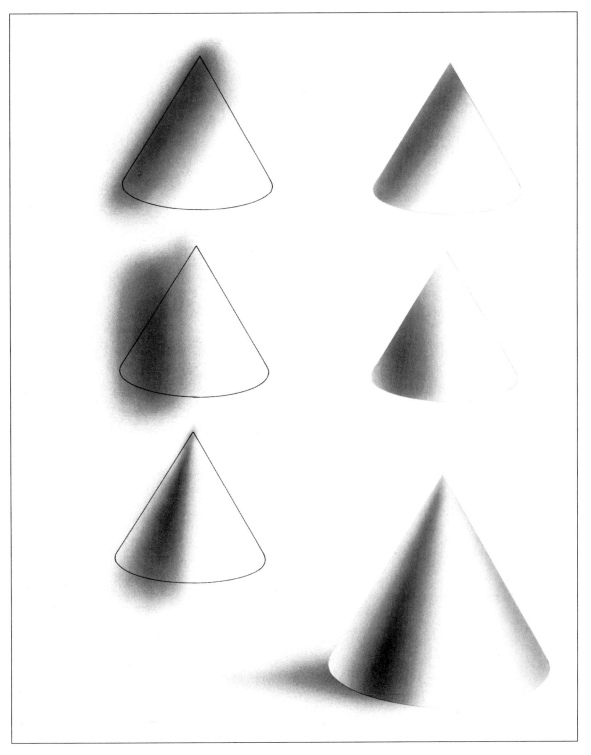

The cone: a difficult shape, which employs a tapering band of airbrushing – achieved by varying the working distance of the airbrush during the sweep. The illustrations show two wrong attempts, followed by the correct rendering.

Exercise 2: Tone and Colour

Here are three more exercises designed to increase you skills in the handling of tone and colour.
You will need:

1. 2 pieces of line board or smooth cartridge paper about 10″ × 9″ and 6″ × 9″.
2. Gouache colours: Rose Tyrien, Peacock Blue, Spectrum Yellow, or:
 Dr. Ph. Martin's liquid water colour: Tropic Pink, Turquoise Blue and Sunshine Yellow.
3. Low-tack masking film.
4. Your usual studio drawing equipment.

Note: Gum Arabic should be added to both mediums making the gouache more translucent and the watercolours less wet.

Exercise A

The purpose of the three grey strips is to provide you with some practice at rendering a curved surface in different degrees of relief. The effects are achieved by varying the contrast between highlight and shadow, not simply by spraying deeper tones. When spraying, remember to turn away from the highlight areas and keep them clean.

Exercises B and C

The gouache colours listed earlier are very close to the printer's primary colours of magenta, cyan, blue and yellow, which when combined at different strengths produce the very wide range of tints necessary in colour printing. When used in the airbrush they produce a similar range of tints by means of overlaying or blending one colour with another.

Work at the same sizes as the illustrations shown, measuring off the sizes of the rectangles and copying them on to your board using an HB pencil. All the rectangles should be drawn up and the masks cut before any spraying is done, because the overspray will obscure the drawings very quickly.

Right: **Exercise A**

Usually when laying one colour over another we want them to cover well and would therefore put down light colours first, i.e. yellow. However, in these exercises the aim is to maintain the transparency of the colours so it is best to start with magenta.

Starting with (B), where the colours are stepped and overlap in full strength, it is first necessary to adjust the tones of the two darker colours (magenta and cyan) by spraying them to half strength only. In the blended strip (C) this happens naturally as the bands of spray are soft-edged. When the half-strength areas have been sprayed, replace the mask and complete the full-strength patches. Finally, remove all the pieces of film and re-cover with a clean mask, thus leaving the drawing clearly visible as a guide for (C), the blended strip.

In (C) the objective is to match the colours of the stepped version. In this exercise do not draw any divisions on the strip because the colours are blended. The tones should be clean with at least a small area of pure colour untouched by its neighbour. The whole strip should blend smoothly, not appearing stepped, but with the colours appearing in the same relative position as the stepped version. Again, to keep the colours clean, remember to turn the work so that you are always spraying into the full strength areas of each colour. Work as close in as you can, thereby reducing unwanted overspray.

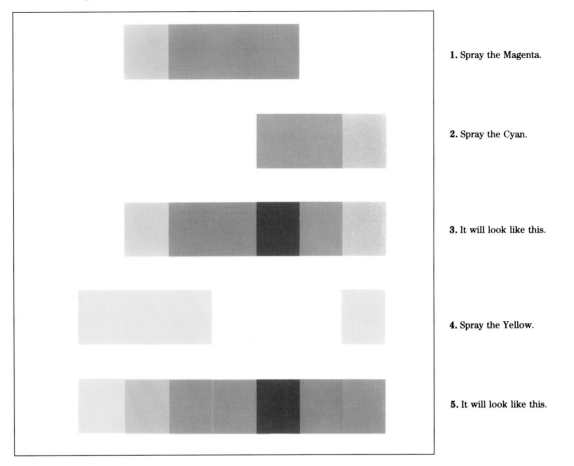

1. Spray the Magenta.

2. Spray the Cyan.

3. It will look like this.

4. Spray the Yellow.

5. It will look like this.

Exercise B: Result

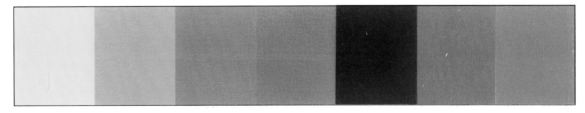

Exercise C

Section 3

Projects

Project 1: Model Figure

With the experience gained on the sphere, cone and cube exercise, we now combine them to produce a little clown figure as our first project.

You can trace the outline opposite for the drawing. The broken lines show how it is constructed, and drafting the basic shapes out carefully will lead to a satisfactory final result.

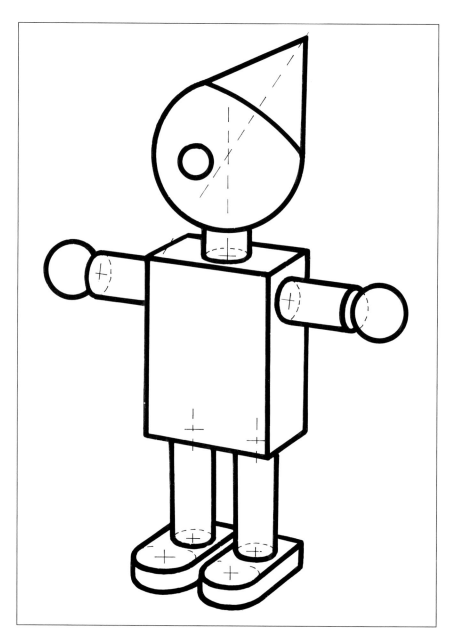

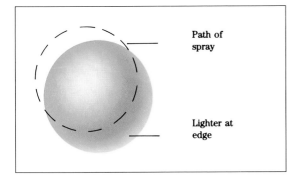

Path of
spray

Lighter at
edge

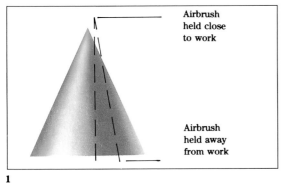

Airbrush
held close
to work

Airbrush
held away
from work

1

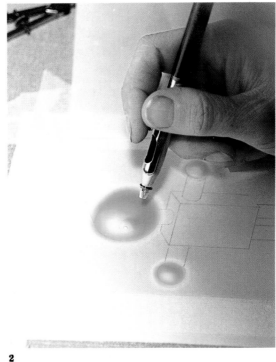

2

1. The spheres which make the head, hands and nose are sprayed using an offset circular movement of the airbrush. This allows the effect of some reflected light in the shadow areas. The conical hat — try to believe you are spraying around the highlight, rather than spraying in the shadow, and vary the working distance.

2. After head and hands are sprayed the shadow of the nose is added free hand.

3. Cleaning up edge of the mask helps to firm down the masking film.

4. Using the edge of a set square to get a soft cast shadow of the neck on the shoulder.

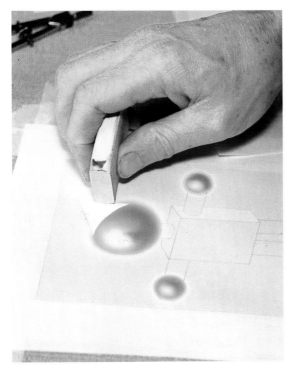

3

4

5. The darker areas are sprayed first finishing with a light tint on the front of the body.

6. Replacing the mask, laying it in place with the flat of the blade.

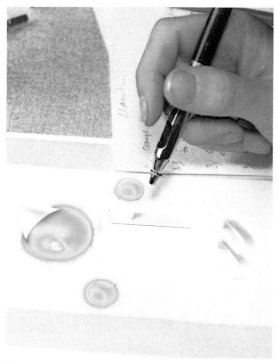

5

6

7. Pushing the mask into its slot with point of the blade.

8. The dark area at the end of the arm sprayed first.

7

8

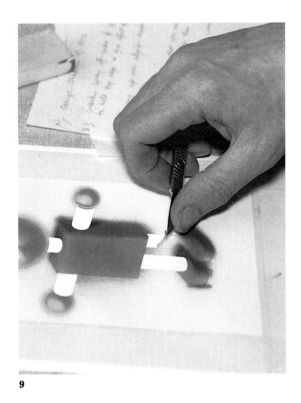

9

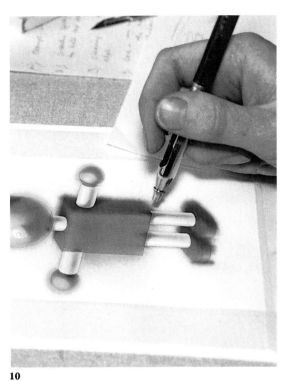

10

9. Lifting leg masks.

10. Spray the arms, leg and neck with straight strokes turning the work as needed. Then finish by spraying the shadows freehand.

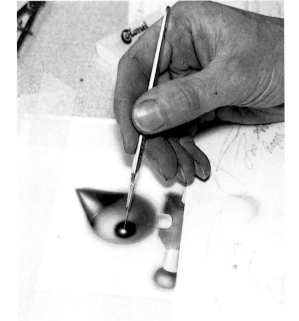

11

12

11. The highlight on the nose was masked, so has left a hard edge. Scrape this edge soft with a sharp rounded blade.

12. Further softening of the nose highlight with an ink rubber.

13. Touching up irregular areas with a coloured pencil.

14. Carefully remove the masks. The main background mask removed first sometimes brings some of the smaller ones with it.

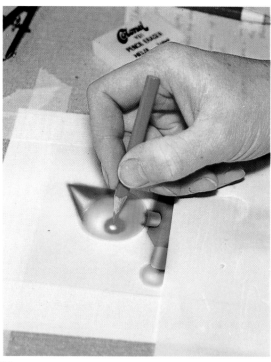

13

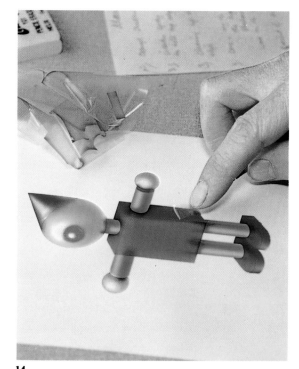

14

15. Clean up pencil marks.

16. Final retouch of any white areas with a fine brush.

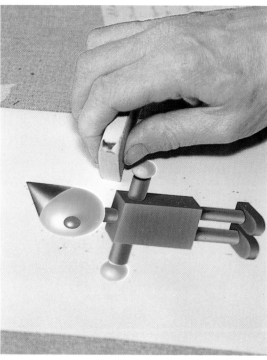

15

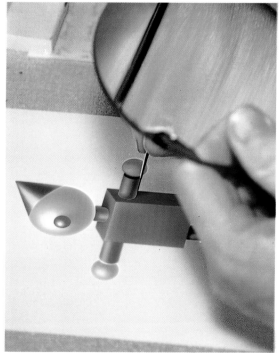

16

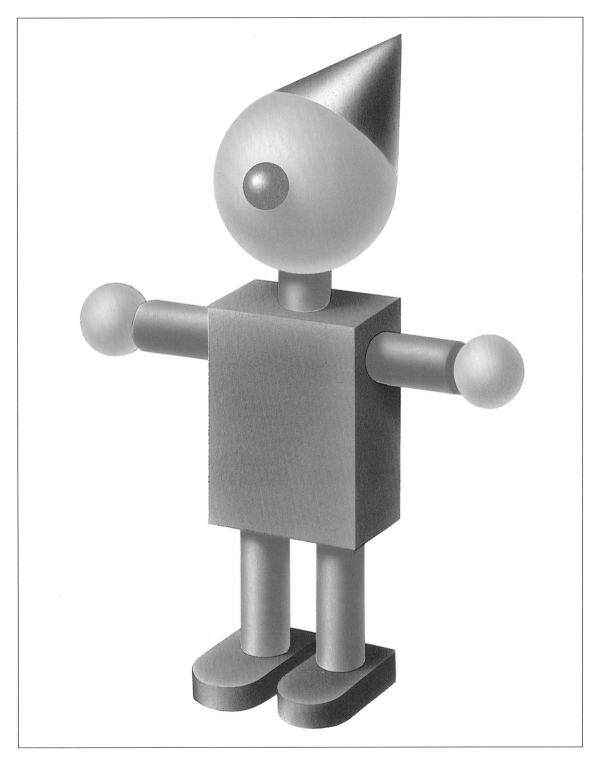

Final Result

Technique Tips: The Cake

This is an example of combining a watercolour illustration with airbrush work.

The cakestand appears to be a bit crude. This is because the final intended reproduction size was only a couple of inches high. Knowing that the hairs on the paintbrush would be difficult to airbrush at that size, the whole drawing was enlarged.

The watercolour part is painted first, the surface is then protected by spraying it with a glaze of diluted gum arabic. This also has the effect of brightening the colours, and incidentally is a good way of blending watercolour and gouache work, where the gouache has dried with a matt finish.

The drawing is then masked with film in the usual way.

1. The clean thin pencil guide lines.

2. The scalpel makes a useful weight to hold part of the mask, bent back to spray the stem and not removed, because it is connected to the side pieces.

3. The same grey mix used for the brush ferrule – don't forget a soft holding edge where the blade is pointing.

4. Reflections off the masking film. Show clearly the parts unprotected, for this reason glossy film is most useful.

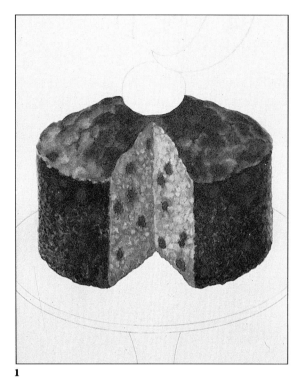

1

2

3

4

5

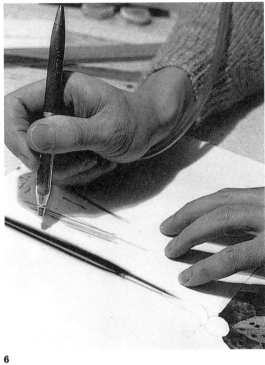

6

5. Note the many practice strokes, before spraying the brush hairs. Note too the piece of mask (the last to be removed, and so no longer needed) used to protect the red splash, its own mask having got lost.

6. Again, plenty of practice strokes, note here the airbrush hose wrapped around the arm to allow a smooth arm movement.

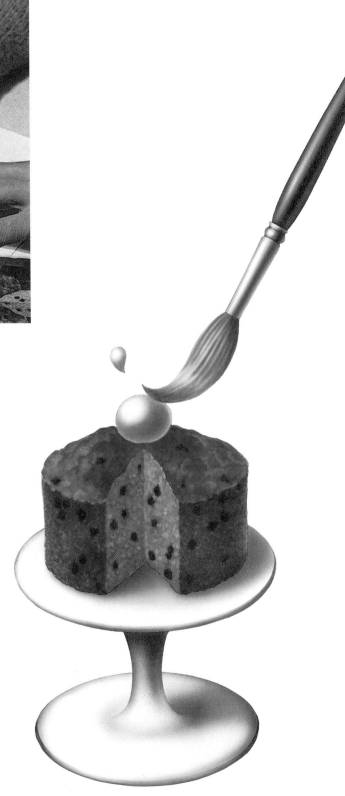

Left: Combined airbrush and watercolour illustration by Roger Gorringe.

Work by other Artists

Right: Airbrush painting by
Roger Gorringe.

60

Left: 'Hot Rods', watercolour airbrush painting by Britt Taylor Collins, USA.

Right: Visual by Paul Langford of ABA Associates, Hertfordshire, England.

Project 2: Diagrammatic Map

The second project is a map. The brief is to produce a simple diagrammatic map to illustrate an article on NATO in a magazine. The project includes a line drawing overlay and dry transfer lettering for captions.

An exercise involving: planning and designing for the airbrush.

Equipment:

Line board
Frisk film (low tack masking film)
Gouache/watercolour
Gum arabic
Overlay material
Usual pencils/pens/scalpels etc/tape

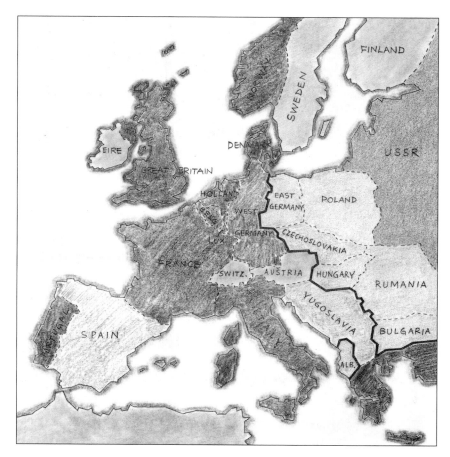

The Rough
The designer has chosen to simplify the coastline to straight lines, giving a pleasing graphic effect and making mask cutting easier. The colours have been chosen to reduce the removal and replacement of masks to a minimum, as you will find as you proceed.

1. Trace the outlines on to the paper, remembering to leave off the boundary lines where no change of colours occurs. The tracing point is a sharpened nail mounted in an old clutch pencil.

2. Lay down light tack masking film (Frisk) and cut with a scalpel and/or swivel knife.

3. Remove mask for USSR. Spray this area pink to half strength (pink is less yellow to allow for (4)). You may also produce a colour key.

4. Remove masks from Eastern Bloc countries and spray with tan colour – this is allowed to cover the USSR area, changing and darkening the pink.

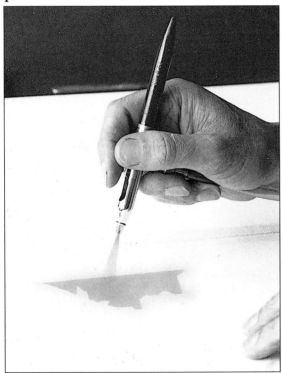

1

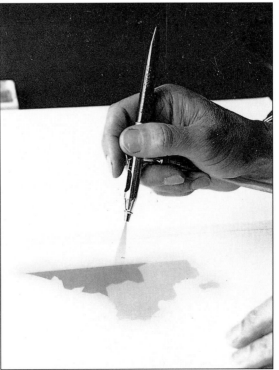

2

3

4

5. Remove mask from Yugoslavia and spray lightly with the same tan colour again, allowing it to add a further coat to the Eastern Bloc and USSR.

This process of adding layers to darken adjoining colours serves two purposes. Firstly, it means there are no unwanted white lines or dark edges between masks where they have not been replaced accurately. Secondly, it guarantees that there will be a tonal difference — something difficult to judge when one area is covered by a mask which has received overspray from earlier spraying.

Follow the same sequence with the green NATO colours. A similar effect could be obtained by lifting all the masks to begin with, replacing them after each area has reached the right colour and tone. But it will be appreciated that it is quicker to remove masks than replace them, thus saving the paint in the palette from drying out before you have finished with it. It also gives the opportunity to see the final effect before going on to the next colour range.

After replacing masks on the USSR and Eastern Bloc countries remove masks from the neutral countries and spray with grey. Replace these masks and remove all those on the sea areas, taking care to burnish carefully around the coastline of the land areas.

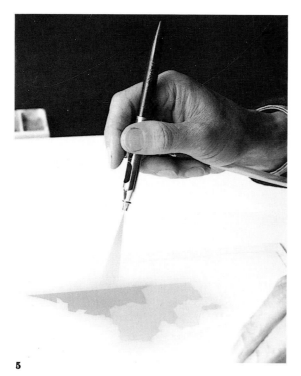

5

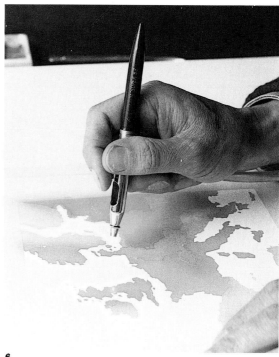

6

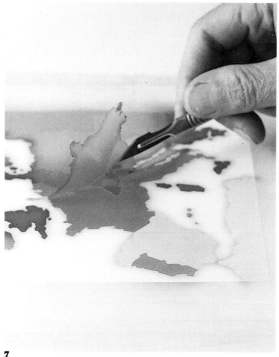

7

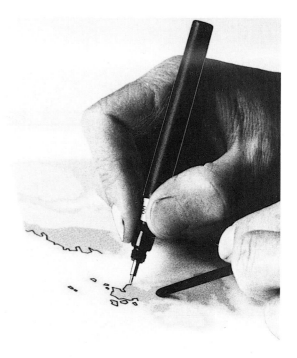

8

6. Spray the blue around the coastline. So far gouache and gum have been used. For the sea, change to liquid watercolour which will give a finer shading. Take care that it does not creep under the mask. This risk can by lessened by a) spraying away from the mask as much as possible., and b) thickening the colour with gum — this last to stop bleeding by capillary action.

7. The big moment! Remove the masks.

Tidy up with a scalpel and a fine paint brush. Coloured pencils (very sharp) are also very good, especially with pale colours.

8. Cut out an overlay of tracing film and tape it to the top of the artwork. Hold this against the drawing with the wrong end of a paint brush, as the film picks up grease from fingers all too easily. Use a ruler to draw the outline of the land areas in black ink on the overlay of the completed map.

Add the printer's registration marks to the board and the overlay prior to putting down the captions. Dry transfer lettering may be used for this purpose.

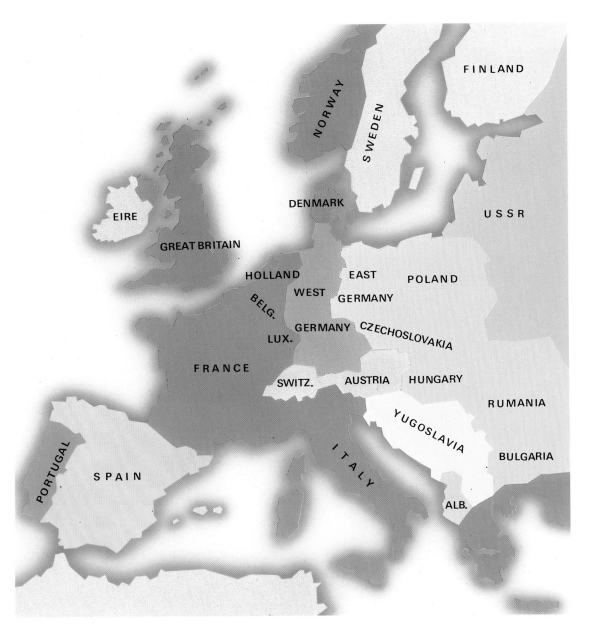

Final Result

65

Work by other Artists

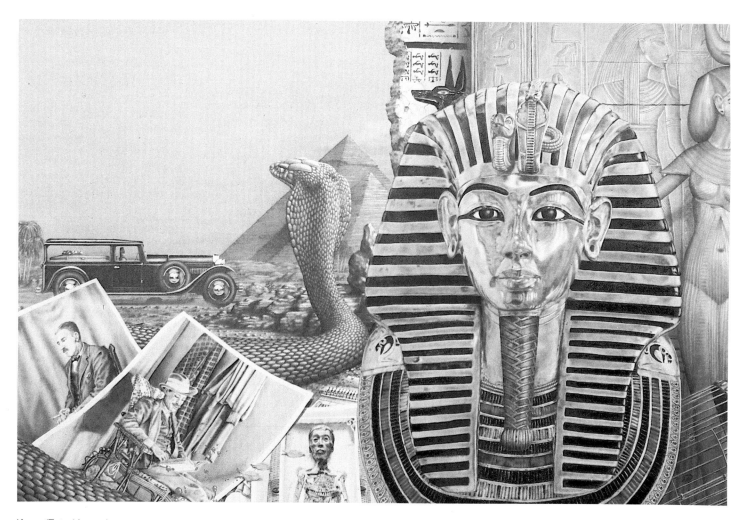

Above: 'Tutankhamen',
composition by Steve Weston
of Linden Artists, London.

Above: 'The Ship of Ecology',
etching — handcoloured with
airbrush, by Curt
Frankenstein, Illinois, USA.

Above: 'Atlas of Peru',
composition by Steve Weston
of Linden Artists, London.

Project 3: Human Figure

The fine gradation of tones obtainable with the airbrush would seem to make it very suitable to render the smooth texture of human skin, and up to a point this is true, but there are problems. Within the sharp outline, almost all the spraying is either freehand (by this we mean without using fixed masks) or by using hand held masks to give a soft edge.

To someone still learning the art of airbrushing (that is all of us!) choosing to illustrate an athlete allows us a break from the difficult skin areas, with the small amount of clothing being worn.

The possibility that a beginner will produce a result somewhat harsh is also more acceptable on this subject, than it would be with, say, a female nude.

The first picture is our original reference photograph. We can improve on the photograph, of course, by completing the front runner's head and leading foot, using other references or a model.

Drawing out is a problem when a lot of free hand spraying is to take place, since heavy spraying of dark colours quickly obscures the pencil. A worse problem is that the binding agent in the paint acts as a fixative, even when the paint is extremely dilute.

As well as fixing the pencil, making it difficult to remove, the paint also darkens and shows up the pencil marks especially on the lighter areas. Despite this, more care than usual must be taken because it is a way of instilling in the mind exactly what you are doing: starting a job and just spraying away hoping for the best is really a waste of time.

1. Use a soft pencil (B or 2B) pressing very lightly. That way most of the surplus pencil will be lifted off by the frisk film. You can see this (illus. 1) on the masks that have been removed and stored on the backing sheet taped above the drawing.

The film has been rubbed down extra hard, to take off as much surplus pencil lead as possible, removing any more by dabbing with a plastic rubber.

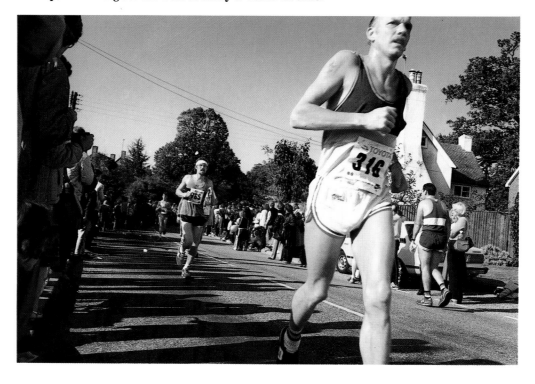

1

Choice of colours: a suitable colour to give a good basic male caucasian flesh tint is burnt sienna. Unfortunately this is not usually a good spraying colour especially if poster or gouache is being used, it being an 'earth colour'. So some experimentation may be necessary, for example spraying the shading with black first, then an overspray with orange/red dye to arrive at the desired colour.

We have used Dr Martins coffee brown.

2. The very deep shadow under the man's shorts is sprayed first, for no other reason than that since it is dark and will need several coats you can keep returning to it. We have gone back and are on the 4th coat here.

2

3

3. Keep referring to the reference material for leg muscle formation rather than relying on memory. It's all part of knowing exactly what you are doing and having complete control of the job.

4. Too much overspray has caused a sharp edge to the right of the thumb from the mask used to shield the fingertips of the left hand. The edge of a piece of acetate is lined up exactly and the tone is matched. This slightly hit and miss adjustment is OK here since the whole hand and wrist is in deep shadow and any slight difference will not be noticed.

4

5. Acetate mask covering the thumb. Keep the contrast of these hand details very high since when the overall spray is applied to throw the arm into shadow, contrast will be lost.

6. Spraying the left hand and wrist to put it into shadow, all the other flesh areas are uncovered, so be careful of overspray. Putting the other masks back would have made judging the tone more difficult.

5

6

7. Although the small background figure has been simplified, extreme care must be used to work so close. If you do not feel ready to work this close, but would still like to try the exercise the background figure could be left off. He is there to give impact by accentuating perspective.

8. By chance the acetate loose mask used on the thumb of the main figure fits the knee of the small one.

9. Back to the main figure: the clothing should be fairly straightforward, so be careful to follow the form of the body and to carry the shading and folds from one colour to the next. Also by spraying a soft

7

8

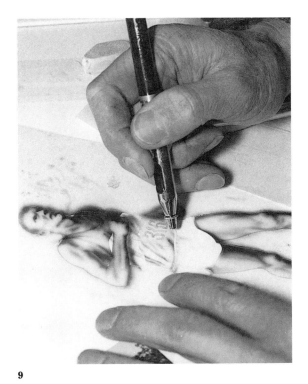

9

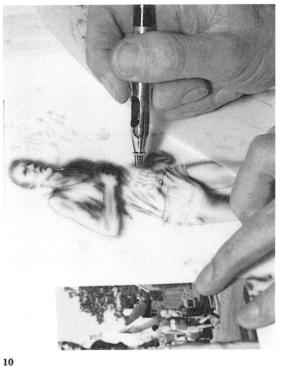

10

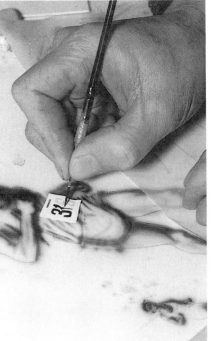

11

12

line just inside the edge of the vest a thickness is given to the cloth.

10. The pale blue part of the vest can be sprayed lightly over the folds already put in at the same time as the white band and shorts.

Applying the paler blue, don't just spray an all over coat, but follow the shading or a dull veiled look will result.

Do not forget the shading and possibly yellowish highlights on the red tape around the runners' shorts. These little touches can add considerably to the final effect.

11. The number is painted on with ink highlighted with white gouache before the folds are sprayed in with a yellowish grey to vary the colours of the whites in the picture. The same technique is used on the sole of the leading foot.

Back to the smaller figure: first the black shorts are sprayed, shading where needed. You can, if you wish, leave the mask off the shorts while spraying the blue top, as a small amount of blue overlaying the black will make it richer and do no harm.

Since we intend to spray a background the outer mask has been removed but great care must go into burnishing the remaining pieces some of which are tiny.

12. Clean up with a plastic eraser, then check that no small piece of mask has been disturbed.

13. Working close to the feet, spray with black to a dark grey the shadows of both figures.

With a warm brown, spray the ground, turning the work to make use of the natural sweep of the arm. A few streaks of the brown mixed with some of the black introduced into the sky will give a sense of movement.

14. Blue streaks form the sky: the colours of the ground can be improved or adjusted by overspraying parts of it with the sky blue.

Carefully remove the masks and clean up as usual with brush and coloured pencils.

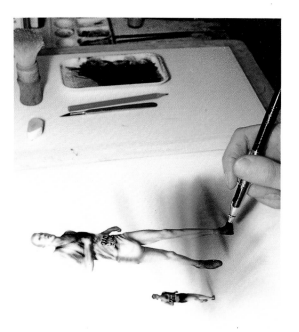 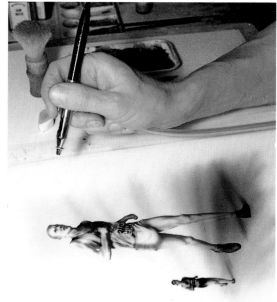

13

14

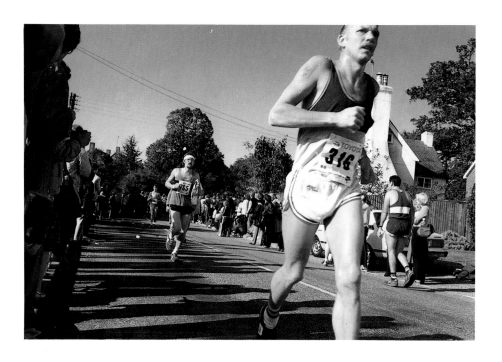

Final Result

Project 4: The Eye

If you do not feel ready yet for a project as advanced as the running figure, a good alternative is this drawing of an eye.

The stylised version we show here provides useful practice in free airbrushing and loose masking without a lot of laborious drawing. Using as references: our illustration or magazine photographs and/or mirror. Make rough pencil sketch, then simplified trace, or use trace pattern in the back of the book.

Using only enough frisking film to cover the drawing, allow a 1″ overlap and cut the main mask removing that portion covering the iris, leaving the wedge shaped highlight in place. The texture in the iris is an exercise in loose masks (paper and acetate). Soften with free spraying, and since it requires considerable skill in close work, it should be tackled first in case an accident should make it necessary to start again. The lashes should be sprayed early in the project for the same reason. Unfortunately this is not possible, but it is worth remembering that if the flesh of the lids are kept simple it is more easy to clean up the tips of the lashes should they be a bit shaky.

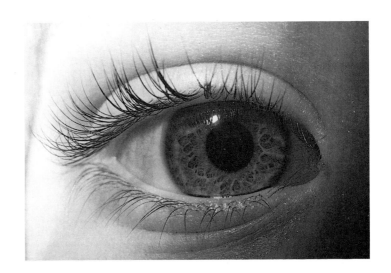

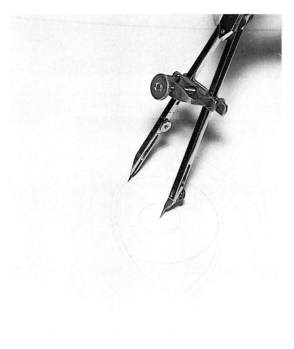

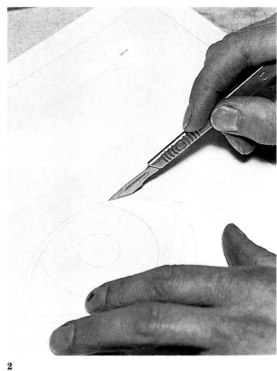

1. Using your specially sharpened pair of dividers, used in the sphere exercise, cut the iris and pupil mask.

2. Smooth curves are best cut with the scalpel at a low angle.

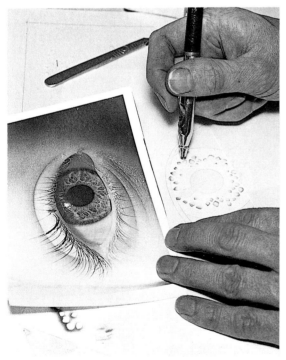

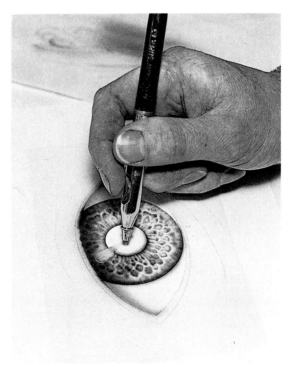

3. Using acetate or stiff paper, cut irregular holes for the pattern in the iris, spray around the edges leaving the space in the middle of the hole paler. Consult your references as often as possible. Our main mask can be seen under the photograph bottom left.

Copying your own reference, or our final picture, darken and finish the iris pattern.

4. The edge of the iris is darkened with black, and the shadow of the lid and form of white are sprayed in at this stage.

1

2

3

4

75

5. Spray the pupil black, lift the high light mask and soften the edge with a scalpel first.

6. Then use an ink rubber. Next repair the iris pattern and blend in the eyelid shadow into the top of the highlight, with the airbrush using the iris colour you've saved.

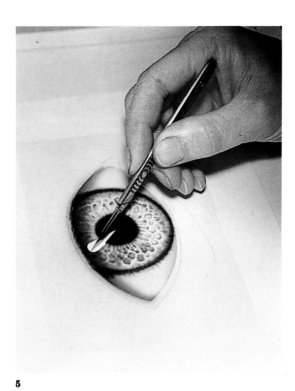

5

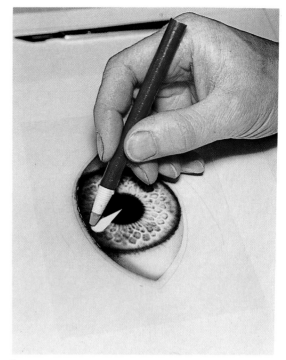

6

7. Cut a variety of curved pieces of stiff paper as masks for the skin folds. The eyelid edges should have been masked with film.

8. Spraying the lashes, practice beforehand on spare paper, by starting each stroke at the base of the hair with a bulbous root.

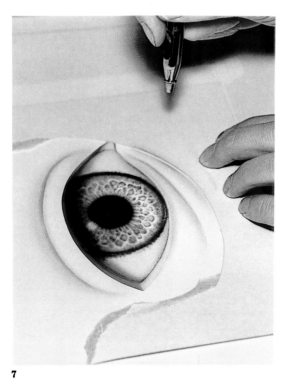

7

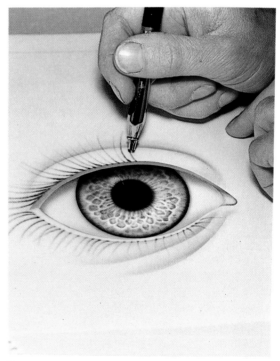

8

76

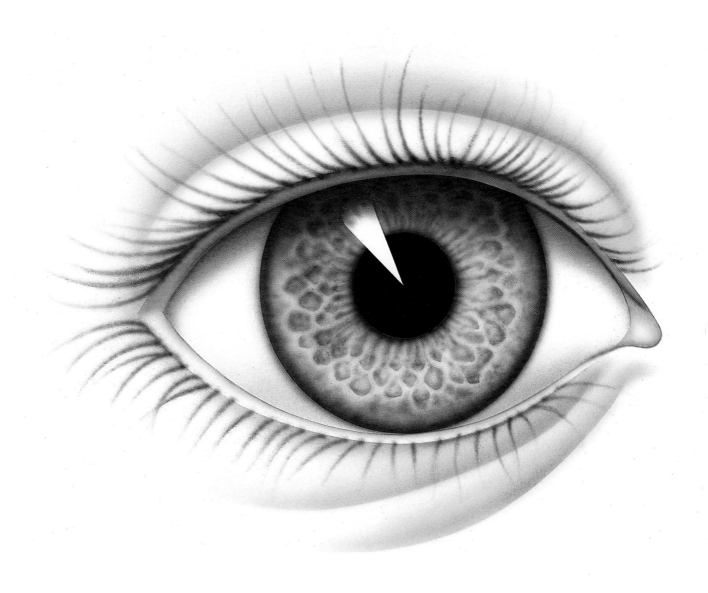

The Final Result has been worked on with free airbrush work. Note the hint of yellow in the white of the eye, and the darkish soft line along the base of the lashes.

Work by other Artists

Right: Three illustrations from a classroom anatomy chart (marketed for high school and college level students) by David Mascaro, Medical College of Georgia, USA. The media were transparent and opaque watercolour, using both brush and airbrush. They are described as follows:

(top) The Eyeball, ¾ front view, opened and partially dissected.

(centre) The Normal Eye, superficial view.

(bottom) The Normal Eye, dissected to show anatomy of the orbit.

Left: Promotional poster (acrylic) for Reebok International by Bryan Robley, Nevada, USA.

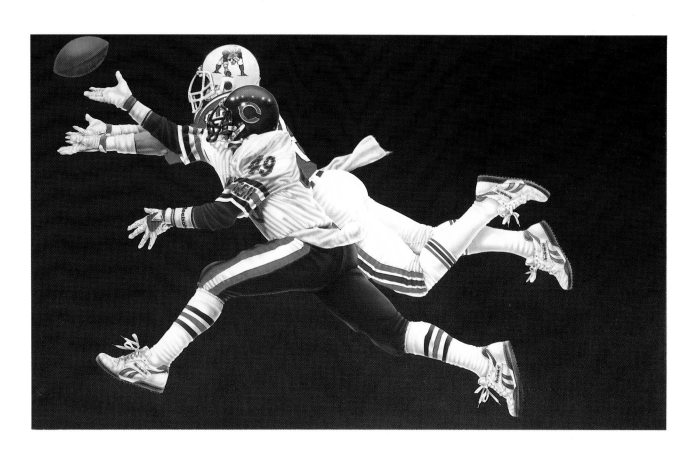

Above: Superbowl XX poster for NFL and Reebok International; Right: Monday Night Football poster for ABC Sports. Both By Bryan Robley, Nevada, USA.

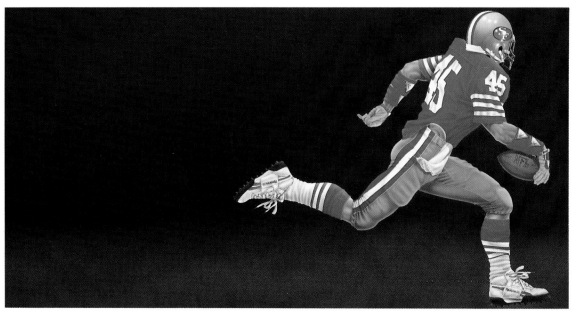

Left: Promotional poster for
Salomon Boots and Bindings
and Roffe Skiwear, by Bryan
Robley, Nevada, USA.

Project 5: Lettering

A formal sample of airbrushed lettering always looks good in a portfolio. For this project we have chosen a 'jumble' of different styles. Some of them appear to be complicated, but are in fact relatively simple to achieve. You of course can choose any word you like; our college students often chose to write their names as they could use it as title to their area in the annual exhibition.

Whatever you decide to do, as always, draw it out very carefully, treat the drawing out stage as a rehearsal for the final Artwork.

1

2

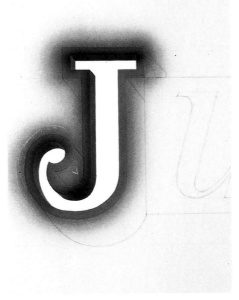

3

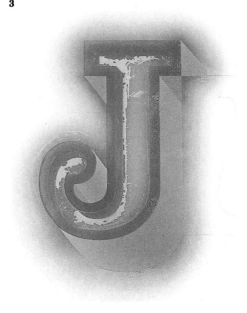

1. Shows this very light pencil work and the outer thin front face mask has been removed for spraying.

2. The outer front face and the inner shadow have been sprayed and the masks replaced. On a fairly easy style like this the areas can be sprayed in any order but it is a good idea always to do the smaller ones first because there is less stretching of the masking film.

3. The inner face and outer shadow are both finished. Be careful to replace all masks especially if, as here, the next letter is mostly black.

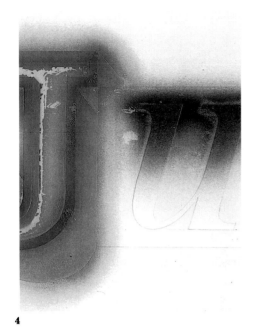

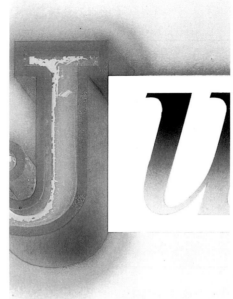

4 **5** **6**

7 **8**

4,5,6. A very effective reverse shadow is straightforward enough, but the trick is to get the part where the shades on the letter and background match, in the middle!

7. The easy part with the 'M' is spraying around the edge against the mask, as there is an escape route if things go wrong. Do the soft shadow when you have used the edge as practice.

8. The yellow is a transparent dye/gum mix sprayed over the red.

9. The 'B' has to be done in two parts corresponding to the two natural strokes of the letter. The masking is tricky but the spraying should be easy.

9

10

Final Result

84

10,11. An old piece of netting laid over the 'L' is simple but effective. The problems are getting the net in close contact with the surface without distorting the shapes of the holes. For the darker colour (blue/green) use a thick paint gouache/gum to prevent soaking the fibres.

12. The 'E' was first sprayed with Indian ink, then the red shadow could be sprayed over it with a dye/gum mix without replacing the mask. The transparent colour does not show on the black.

85

Above: Airbrushed lettering by Mark Lacey for Arrow Holidays, London. Designers: Crace Associates, Ware, Herts., UK.

Right: Watercolour airbrush composition by Mark Lacey for IDA Advertising. (Client: Norman Group of Companies)

Left: Watercolour airbrush composition of McDonald's logo, by Britt Taylor Collins, Georgia, USA.

Below: Airbrush composition, Chicago TV/WLS – Channel 2, by Britt Taylor Collins, Georgia, USA.

Project 6: Natural Forms

A slightly more advanced technique is required here to produce a complex illustration of this nature.

The main areas are hard masked with Frisk film, but loose masking and free-hand work should be used within these areas to achieve the soft graduations of colour and tone.

Working within an overall hard mask gives protection against the wrong stroke and generally allows you to work more freely and quickly.

We suggest liquid water colour/colour gum mixture because some colours will be mixed on the artwork by overspraying and you will have finer control when working close in.

The Rough

1

2

3

4

1. The rough is produced using coloured pencils on layout paper. Layout paper is thin enough to push through onto your board without having to make a separate tracing.
Lightly dab off excess pencil lead with a plastic rubber. Remember that the ruler must be as long as the width of the masking film, or uneven stretching and bubbles will occur. This is an ideal exercise for the swivel knife, as there are virtually no straight lines.

2. Lift *all* the masks from the marrow area and spray as if it were yellow only, leaving a soft highlight, of course. Replace the masks over the parts to remain yellow and spray a green which is more blue than the intended final effect, leaving the same soft highlight. Stop when the green is the right colour.

3. Spray the broad beans individually using the same technique, but this time spray the green first. Work very close and note that the 'seam' is soft sprayed.

4. Keep the rough taped at the top of the artwork so that it can be flapped down and used as a guide for cutting the main areas of the mask. Cut right through it for those areas needing a sharp edge.

Refer to the section on masking and experiment with acetate loose masks. The lower effect was chosen for the cabbage leaves.

5. Work close to keep the contrast high. Spray dark green for texture and overall form to outer cabbage leaves.

6. The heart is sprayed leaving the veins, and then form is added to the veins.

5

6

7. Give the cabbage veins and some of the heart leaves a yellowish tint, then lift all the masks to add the cast shadow of the basket handle and also the purple tint to the outermost leaves.

8. Replace the masks between work on separate potatoes, with the film being carried on the flat of a scalpel blade. Remember to put the cast shadow of the handle on the potatoes as well.

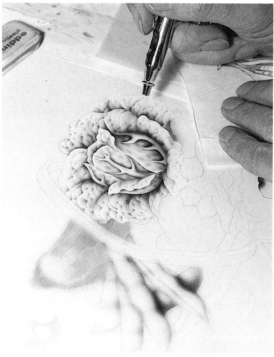

7

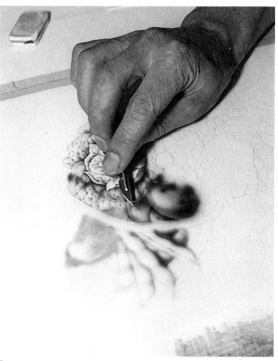

8

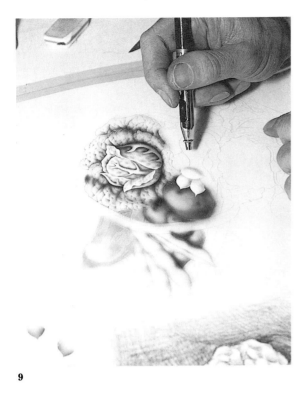

9.

9. Shape the radishes before adding the red.

10. Clean-up any spots with a scalpel as you go.

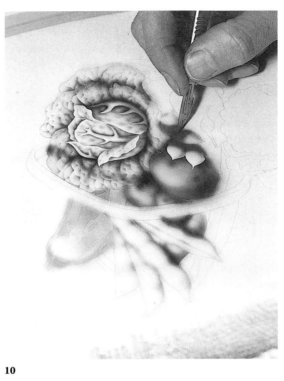

10.

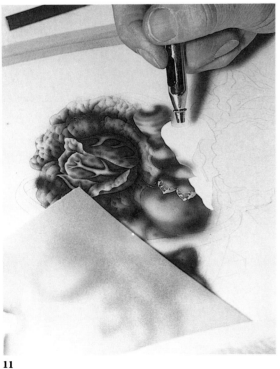

11.

11. After the first carrot has been sprayed and the brown shading put on, spray the next carrot with the brown shading first. This saves cleaning the airbrush too often.

12. Second carrot — don't forget the contrast.

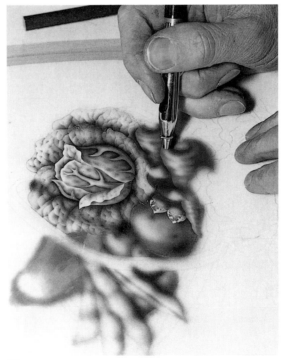

12.

13. Add the yellow to the cauliflower stalks, using an acetate mask.

14. Dab surplus pencil marks off. Note the mask covering the hard window highlights within the softer main highlight.

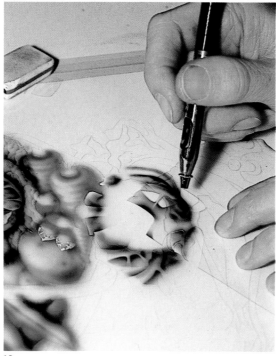
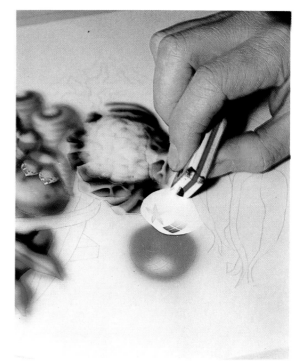

13 **14**

15. To obtain the fluting effect, work freehand along the length of the rhubarb stalks, turn the work to make use of the natural movement of the wrist.
To achieve the sweetcorn effect cut corn-shaped holes in the acetate and aim the airbrush at the edges and the bottom of the holes.
Study the final illustration to see how the sheaths on the sweetcorn were produced, and note the technique used on the mushrooms.
To spray the background, replace all the old masks, or cut a new one to cover the vegetables.

15

92

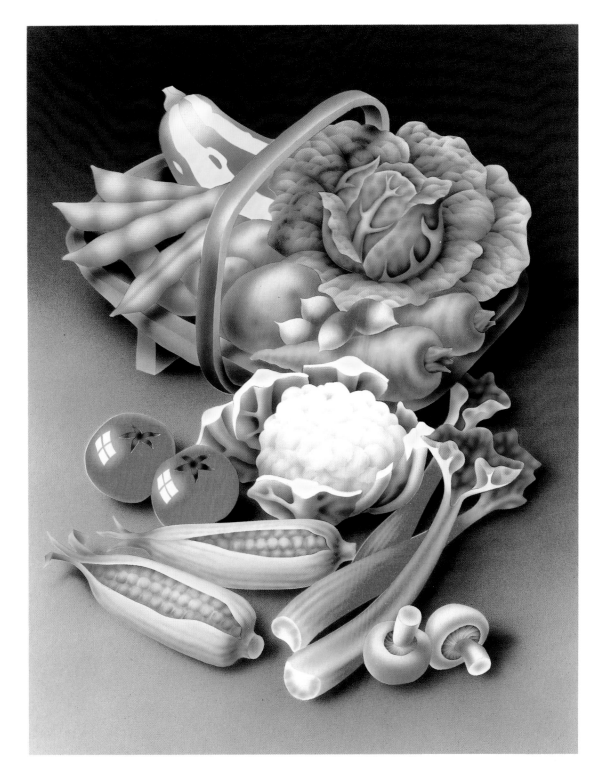

Final Result

Work by other Artists

Above: Illustration of polar bear by Jim Channell of Linden Artists, London.

Right: 'Killdeer Eggs', acrylic freehand airbrush painting by Jerry Gadamus, Wisconsin, USA

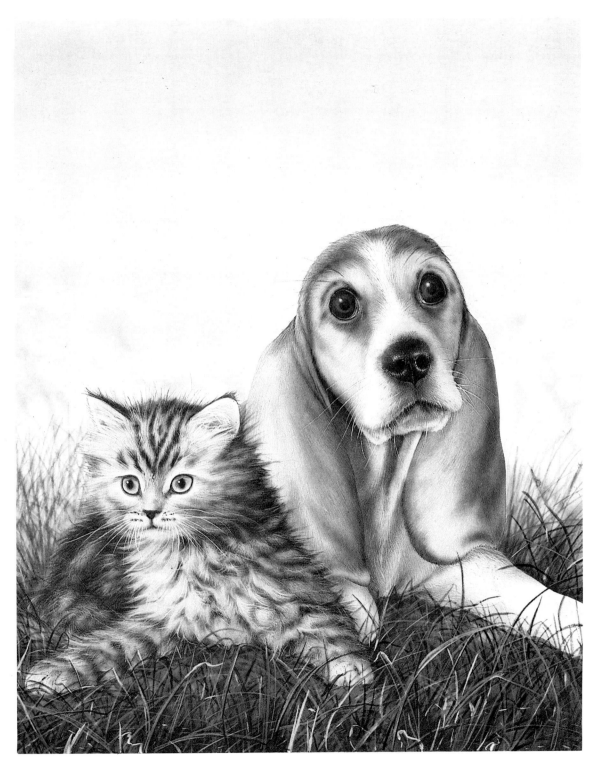

Left: Illustration of dog and cat by Jim Channell of Linden Artists, London.

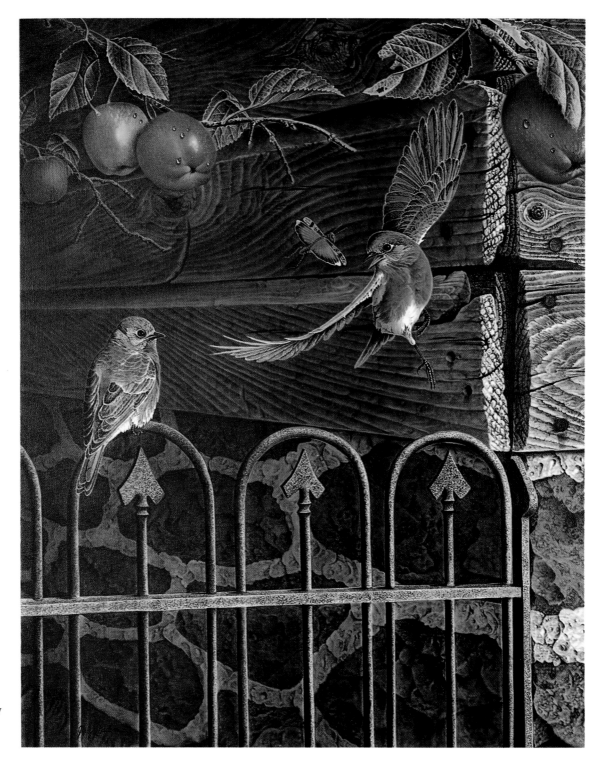

Right: 'Orchard Blue', acrylic
freehand airbrush painting by
Jerry Gadamus, Wisconsin,
USA.

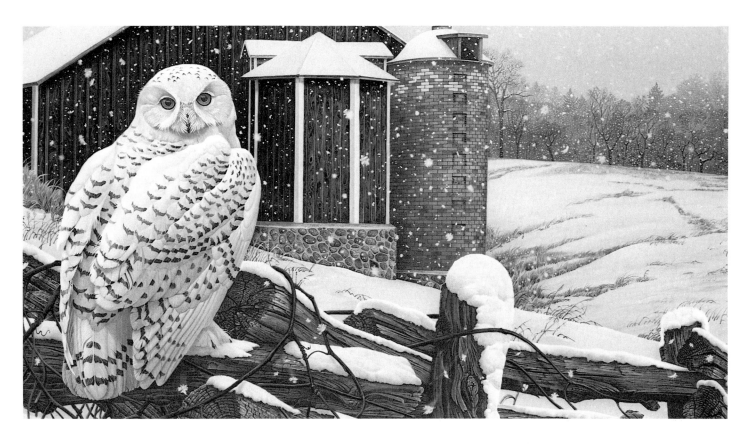

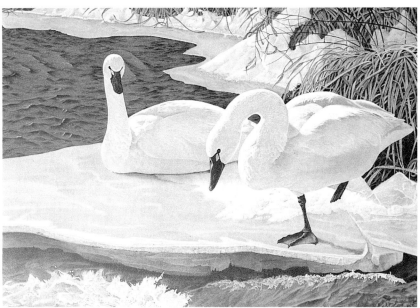

Above: 'Vanishing Red –
Gathering White'; Left: 'Alaska
Rest Stop' (Whistling Swans).
Both acrylic freehand
airbrush paintings by Jerry
Gadamus, USA. (His freehand
technique is explained as
'without the aid of stencils,
handbrush, masking or the
like. It is all sprayed.')

Project 7: Photographic Retouching (black/white)

The Brief

Your client is producing a small brochure of sports trophies and has only a poor photograph of this particular item which needs coarse retouching for small size reproduction.

The first step is to assess the faults:

1. Lack of sharpness in some areas/lack of contrast

2. Highlights within bowl of cup too strong, making the inside come forward in relation to the front rim.

3. Reflection of stem on underside of bowl, spoiling the shape.

4. Background blotchy and dull.

Materials needed: lamp black/process white/gum/acetate/Frisk film/photograph.

Client's Photograph

1

2

3

4

1. Mount the print and cut some loose masks with acetate, along the lines suggested. Leave enough space between the score marks on the acetate to be able to use male and female pieces of mask.

2. Holding mask A in place, darken the interior of the bowl close to the front rim to make the cup more hollow. Also darken the shadow areas to give more contrast and form.

3. Mask B — overlap the position that mask A was held in, to give a thickness to the rim. Using freehand technique, darken the reflected highlight on the bottom of the bowl, then put in the heavy shading on the right side of bowl and the light shading on the left.

4. Using mask C, darken selected parts of the handles. No need to keep off the background.

5. Using masks C/D/E/F/G, continue the shadow down the right hand side of the stem increasing contrast by following the shadows that are already there. The cut edge of the masks should already be making the picture appear sharper.

6. Using masks G to K, strengthen the shadows on the black base again. There is no need to keep off the background.

5

6

7. Background masked and sprayed all over light grey.

8. Background shaded with black from the top down.

7

8

Final artwork reproduced full size to show the white highlights added to the rim and stem to give extra life to the photograph. Compare with the original. The small reproduction is per the brief on page 98, hence the instruction for only coarse retouching.

Final Result white highlights added to rim and stem to give life!
Compare with original photograph.

Work by other Artists

Right: 'First Step' – the two photographs (original, then retouched) show the removal of an unwanted subject in the background. Retouching by Kathy Haley-Falls of Michigan, USA.

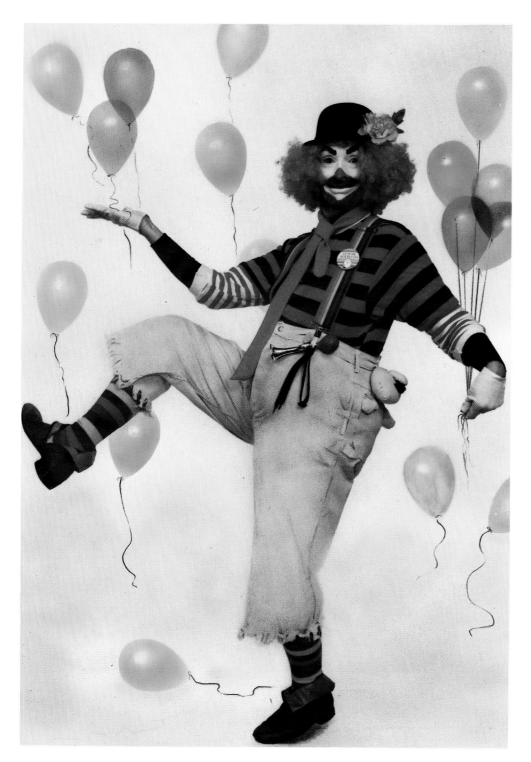

'Clowning Around' – an example of award-winning retouching By Kathy Haley-Falls of Michigan, USA. The original is shown above; all the balloons in the version on the left were done with airbrush.

Project 8: Book Cover Illustration

We thought it would be useful to include the design and execution of the cover of our own book, as a project, since it entails a few interesting issues.

There is a loose rough, making use of unusual masking materials in rendering the clouds, and it provides practice in clean bright technique; in particular, blending colour into black without a hard 'step' showing.

The Rough

1

2

3

4

1. A rough visual of the idea has been produced and an accurate tracing of this is made (Refer to trace pattern p.143).

2. Indicate the position of all the colours on the tracing before tracing down. It is important to be absolutely clear about how you are going to proceed when working on complex illustrations.

3. The lettering is in perspective so take care to draw the vertical lines back to the varnishing point when tracing down.

4. Note that the lettering shadow has the same vanishing point as the window opening. Attention to details like this at the early stage will produce a much more accurate and satisfying final result.

5. When the image has been traced down, go over it carefully correcting and cleaning up any inaccuracies in your drawing (don't simply trust the tracing).

6. Look at the finished illustration on p.111 and decide what is drawn in black. Transparent dyes are to be used for this project, so the black will show through.

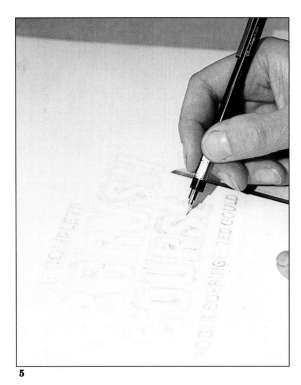

5

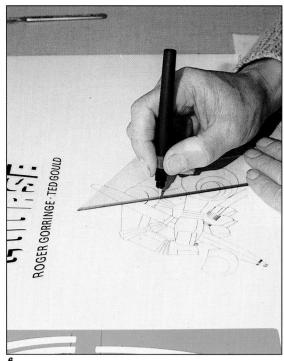

6

7. Use black waterproof ink with pen and brush to draw those areas which are solid black. These areas are shaped so as to provide an edge for the other sprayed colours.

8. When starting to mask, cut away a strip of the backing sheet before laying it down, then progressively smooth it flat with a straight edge (as demonstrated in 9.).

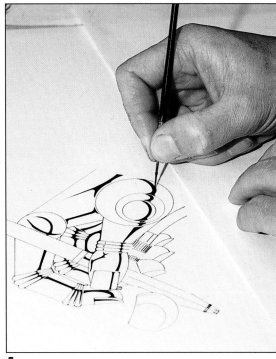

7

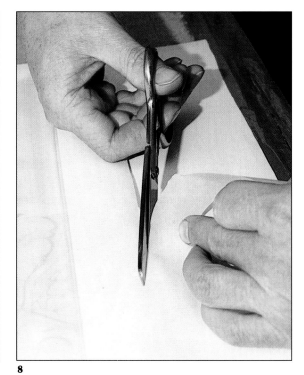

8

106

9

10

9. Note that a straight edge large enough to go the full width of the film is used — if it is much less, the film will stretch at the edges.

10. The next step is to 'blend-in' the black areas. Work close and continually test the spray on spare paper.

11

12

11. Add the orange tints reflected from the sky (which is not yet sprayed).

12. Replace the larger masks. Lift them up with the flat of a scalpel blade.

Replace the smaller masks. Stab them with the point of the scalpel.

13. The blue has been sprayed on the hand. Now remove all the masks from the orange sky and burnish down the replaced hand masks.

14. Cut the cloud masks from thin card. Mount 'worms' of Blu-Tack or kneaded rubber to the underside and stick them into position on the artwork.

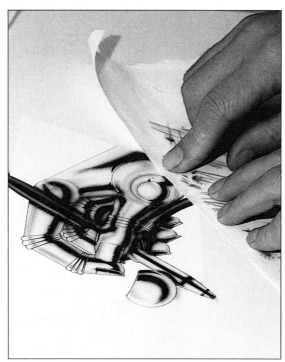

13

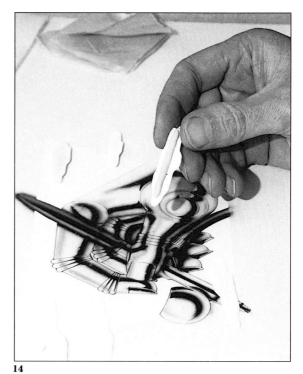

14

15. All masks are in place ready for spraying.

16. Spray the title lettering and the orange sky at the same time. Change the angle of the airbrush whilst spraying to keep the soft edge to the clouds. By contrast to the close work involved when spraying the hand, the airbrush should be held further from the artwork to shade the sky evenly.

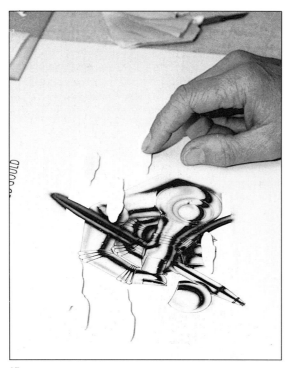

15

16

17

18

17. Now spray the cloud shadows.

18. Before spraying the blue sky, mask the clouds in the same way as for the orange sky, but mount fatter 'worms' to the masks to achieve a softer edge. Mask the stars with small blobs of masking fluid applied with a straightforward paper clip.

Note When spraying large areas, care should be taken to cover other pieces of artwork or valuables in the studio, otherwise you may find that they have been covered with a thin film of paint. Small spray booths can be purchased from some manufacturers for safer working, or, alternatively, you can make up a simple cardboard box open on one side for this purpose. It is also advisable to obtain or make a nose and mouth mask to protect your lungs.

19

19. Spray turquoise blue slightly unevenly over most of the sky background.

20. A darker, richer blue is achieved by spraying magenta over the turquoise blue. Overlaying colours on the board in this way produces a more vibrant effect.

20

21. Remove the mask covering the spray jet shown coming from the airbrush and blend the blue jet to make it appear as if it is spraying its own sky background.

22. Adjust the colour of the blue highlights to match the sky.

At the same time give more form to the hand by darkening the fingers within the fist.

21

22

23. Soften the clouds using an ink rubber.

24. Remove the masks and tidy up the illustration by hand. Add the light yellow reflections using a coloured pencil.

Finally, add the graph paper grid at the bottom of the drawing. Use a soft 4B pencil to do this.

23

24

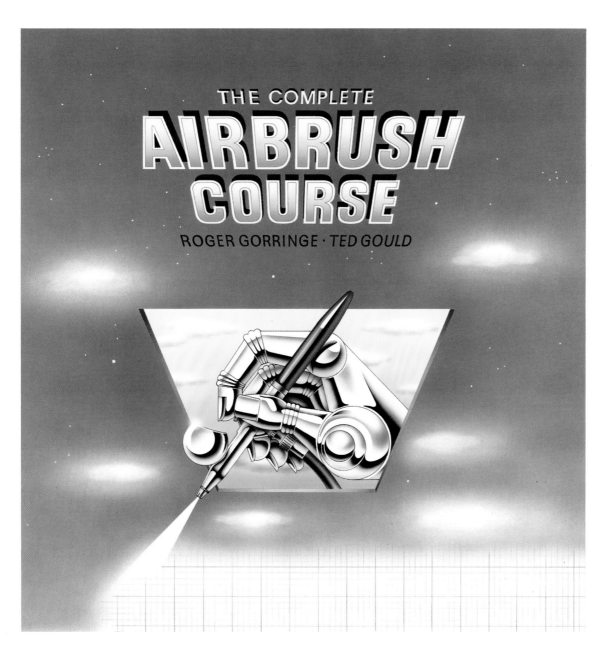

Final Result
Soft white highlights have
been added.

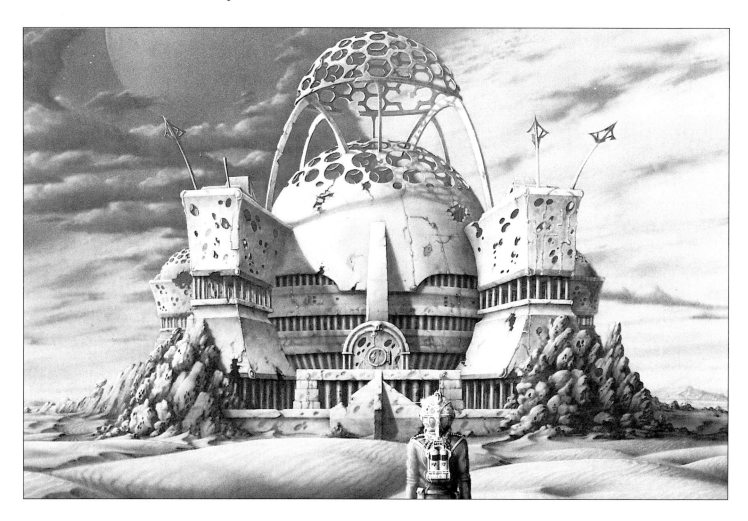

Above: 'A Different Light' by
Steve Weston, Linden Artists,
London.

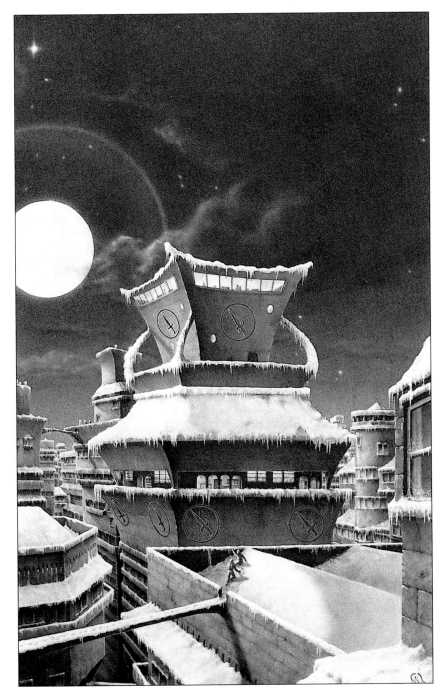

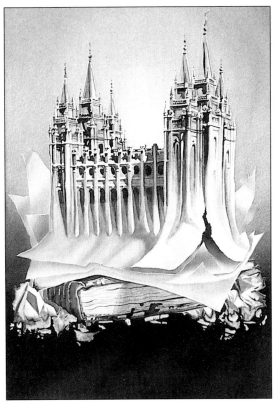

Above: Cover for 'The Mormon Papers', by Britt Taylor Collins, Georgia, USA.

Left: 'The Frozen City' by Steve Weston, Linden Artists, London.

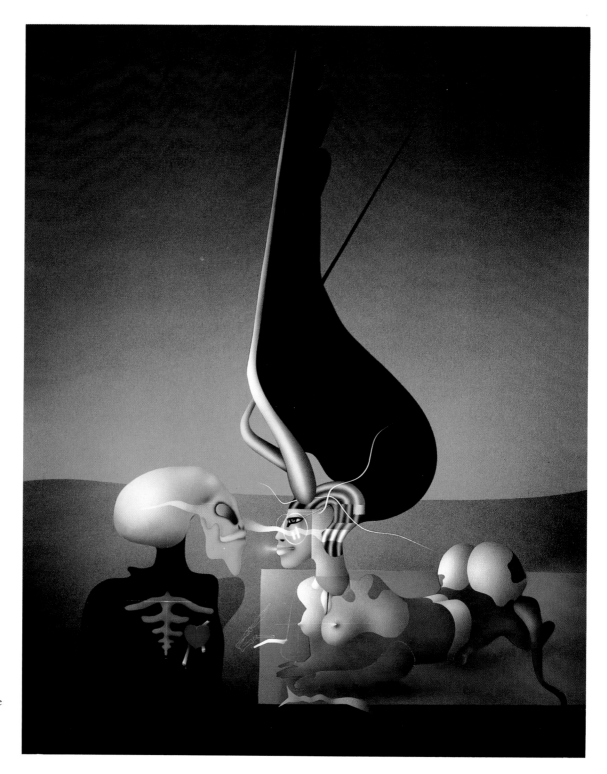

Right: 'Tod and Sphinx' acrylic airbrush painting by Paul Wunderlich, Hamburg, Germany, 1979.

Above: Airbrush painting
using gouache colours by
Dennis Hawkins, London.

Project 9: Technical Illustration

The clean positive image the airbrush produces is ideal for mechanical or technical illustrations.

We have chosen a fairly simple item to illustrate, in that it does not involve any laborious repetitive components such as cog wheel teeth.

We encourage college students to invent similar projects for themselves, based on objects of personal interest, since an understanding of the subject makes for more accurate and satisfying work.

1. The client required a full colour version of the line & tone cutaway drawing of a boiler.

1

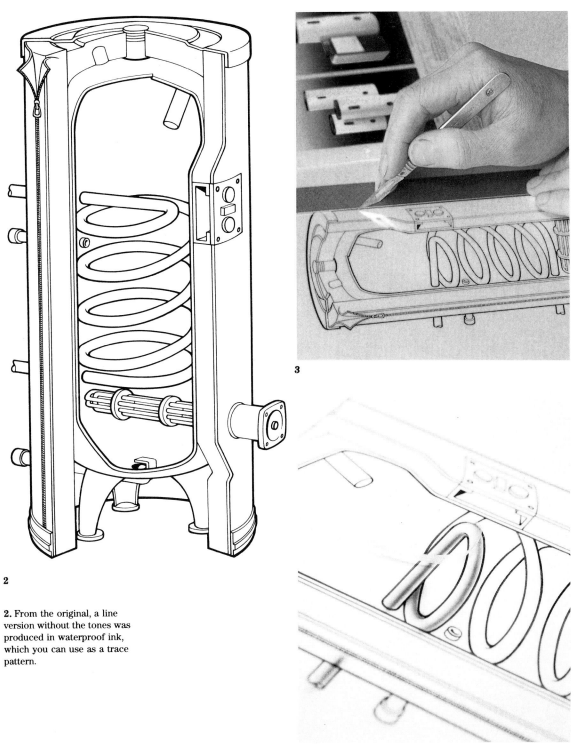

3. The reflection of the blade shows that the film has been laid over the line drawing. Using a ruler for the straight lines cut every part of the mask at the outset. We are using the line artwork as our base, so avoid re-touching it with white paint since this will lift with the masking film. Use a knife instead.

3

4. When spraying the internal heat exchanging pipes, part of the mask has been replaced to protect the overlapping pipe at the top.

2

2. From the original, a line version without the tones was produced in waterproof ink, which you can use as a trace pattern.

4

5. Use a piece of paper or acetate, held in your free hand at the points marked with the arrow.

6. The insulation material required a rough texture. If you do not have a spatter cap a combination of uneven spraying and toothbrush scattering works well.

5

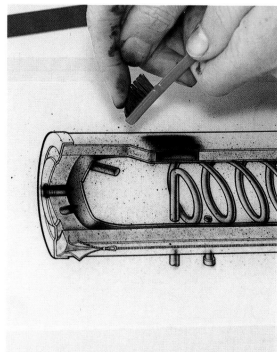

6

7. More careful spraying, using loose masks held well clear of artwork will give form to the insulation. Vary the colour of the greys when putting in the heating element and do not forget the little touches such as shadows of the smaller pipes.

8. The use of different blues on the internal surface (greenish highlights, purplish shadows) adds interest. Be careful to keep the shadow of the pipe work well clear or the pipes will look as if they are touching the blue surface.

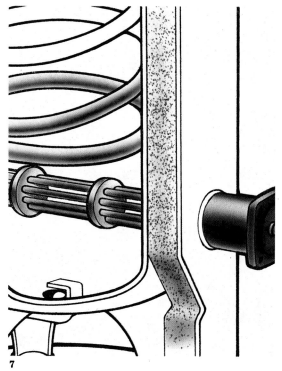

7

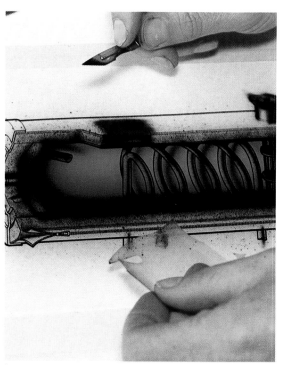

8

Final Result
The rest of the metal work
should be fairly
straightforward by now, keep
the contrast high on shiny
parts.

The colour of the outside of
the jacket was taken from the
brochure cover, seen in the
first illustration. Red switch
and zipper details are best put
in with a brush during
cleaning up.

Technique Tips: The Door Lock

Here we have an example of an exploded drawing of a simple door lock.

1. Shows a completed section covered over with a fresh piece of film. This saves replacing lots of little masks, but can only be used if there is clear space around.

2, 3. show the wooden handle sprayed for form first, then for grain pattern.

4. Shows clearly why airbrush drawings are nearly all hours of laborious masking for a few moments of actual spraying!

1

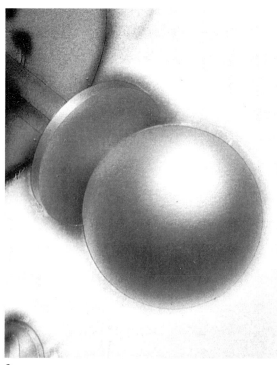

2

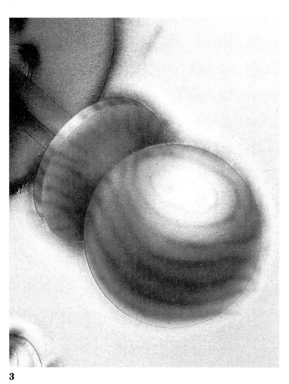

3

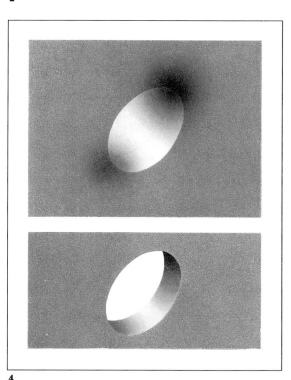

4

**Exploded drawing
of a door lock**

121

Work by other Artists

Right: Exploded drawing of part of a Post Office Pre-Sorting Machine by Gerrard Brown, London.

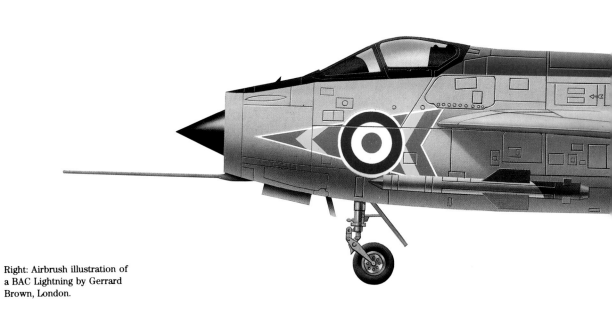

Right: Airbrush illustration of a BAC Lightning by Gerrard Brown, London.

Left: Technical illustration of a two-stroke piston engine, constructed from plan drawings. Airbrushed gouache and watercolour by Brian Oxley, Gilchrist Studios, London.

Section 4

Specialised Areas

Vehicle Customizing

Customizing vehicles is a specialised field involving different techniques for masking and airbrushing.

A few of the problems involved are listed here:

1. Size and movability of the vehicle — this may mean working under difficult conditions — damp, cold, dusty, with poor light, or even outside. These conditions can cause problems with drying times and viscosity of paints, and *damp*, with the possibility of condensation causing blooming. Also the masks will not stick very well.

2. Special paints must be used for durability and their ability to take on hard metal or plastic surfaces. These paints are not celebrated for their ease of use in airbrushes and can attack the plastic parts of some models!

3. Surfaces which curve in more than one direction can make masking difficult and liable to lift.

4. Surfaces which lie in a different plane (vertical and horizontal) cause awkward spraying angles.

The large size of car or van is something you just have to to live with. Try to design the work so as to avoid going too high. Care in design can also help with points **3** and **4**.

An obvious consideration is the length of your air hose. Not just will it reach, but will it scrape against work still wet and, if it is too long, will pressure be lost excessively? A propellant can in a pocket may help here, but pressure control is not easy with these, particularly if ambient temperature is already low.

As regards viscosity of paint, cold conditions thicken most enamel and cellulose paints so before

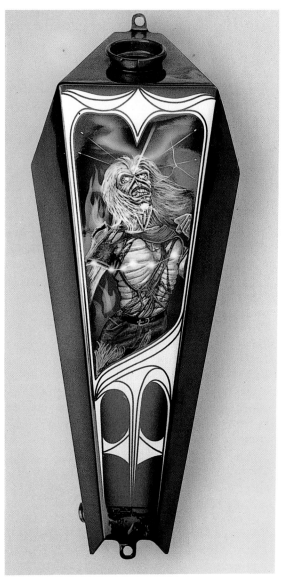

Above: Fuel tank – freehand fantasy design by Jonathon Easton, Taylor's Creative Customizing, Croydon, England.

over thinning and losing opacity, try gently warming by standing the container in warm water. **Do not use direct heat** as these paints are highly flammable!

Drying times are prolonged by low temperatures and a hair dryer blown on the metal surface before work commences can help. Again, keep away from flammable materials, as vapour can enter the hair dryer inlet and ignite on contact with the element.

Damp can be a real problem, as any moisture condensing on cold surfaces and in the air line can get between the paint layers and cause blistering. If the work has to be done out of doors remember to finish before the sun is too low as even after work has stopped evening mists can cause a bloom to occur. Blooming, if on the surface only, can often be polished out with compound but it can take the form of milkiness in clear lacqers, and *that* is 'start again' time.

The *special paints* used in customizing are described as Automotive Acrylics, with some opaque and some translucent. All should be treated as *mildly toxic* and used in well ventilated areas wearing a mask. Thin with 'Acrylic repair thinners'.

As with gouache and water colours, some colours flow better than others and will need a bit of trial and error, They are self solvent so should be used as dry as possible.

The following will make a reasonable starting off range.

Opaque colours Sikkens Autofine (Dutch) Pageant Blue/Cytroen Yellow/Alfa Rosso (Red) mixing black and mixing white, all mix well and give a reasonable palette.

Translucent Metalflake (USA) of which the best three are Fire Red/Regal Blue and Aztec Gold.

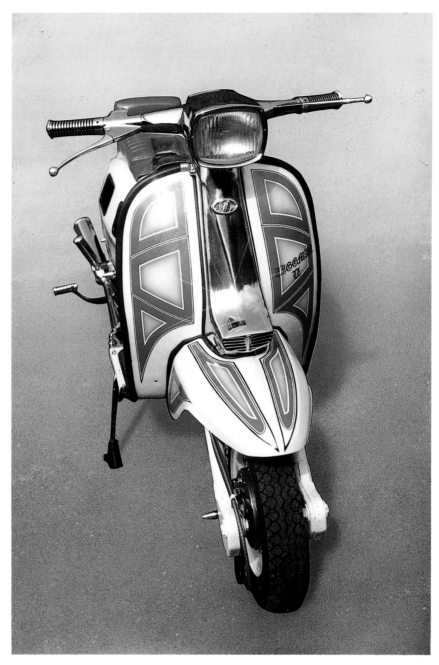

Above: Scooter – showing clever use of narrow masking tape to create a panelled effect that looks more complicated to mask than it actually was. Taylor's Creative Customizing, Croydon, England.

A good *thinner* is fast thinner from Ault and Wybourg (German). Drying times vary between 5 and 20 minutes.

Preparation

If the whole area to be worked on is to be re-sprayed (motorcycle fuel tank etc), then use a matt base colour. If you are applying decoration to already sprayed surface (car door etc) then the area to be worked on should be made matt by leveling with fine wet or dry abrasive paper. This makes marking out much easier and speeds drying by allowing the surface to absorb thinners from the paint being sprayed. Most importantly it makes the top coat of paint adhere properly to the base. Gloss is brought back with clear lacquer.

Masking

Make sure the surface is dry and hard! Frisk low tack film can be used but masking tape will prove most useful because of its ability to bend both ways to some extent. Different widths are obtainable from ¹⁄₁₆″, ⅛″, ¼″, ½″, 1″ up to 2″ or even more. (USA made).

The very narrow widths are most useful for rounded surfaces, the mask being built up with a mosaic of ¼″ lengths.

Below: Freehand airbrushing by Chris Cruz, Florida, USA.

Don't leave the mask on too long as the glue can get left behind.

Don't take the mask off too soon as a tiny amount of paint often creeps under the edge, is prevented from drying quickly and 'strings' when the tape is removed. Any type of loose masking can of course be used.

Protective coatings

Belco lacquer (I.C.I)
Metalflake (USA)
Use the same thinners as for paint

For *professional* use only — iso cyanate lacquer. This is very dangerous, being cyanide based, and can only be used in special booths with breathing apparatus.

The lacquer is applied in 6 coats — thin first to fix and prevent bleeding, then increasingly thick coats for the other five.

Even after six coats the extra thickness of the underlying artwork could still leave the finish slightly embossed. Leave 4 to 5 days, then level with very fine wet or dry paper, finish with a final coat of lacquer, then compound, then T cut (Acrylic).

The Airbrush

As mentioned earlier, the solvents could attack plastic parts of some cheaper airbrushes, so avoid instruments with plastic components. The Badger PK 150 with medium needle and tip is very suitable, or any other similar type. Be certain however to get one that has sealed jars, because of the risk of spillage when working on the different surfaces of a motor vehicle. Pressure may need varying, down to 12 psi. for close work, so a separate regulator makes life easier and a water trap is needed. Try to stop the paints getting into the air intake; putting the compressor in the next room is a good tip.

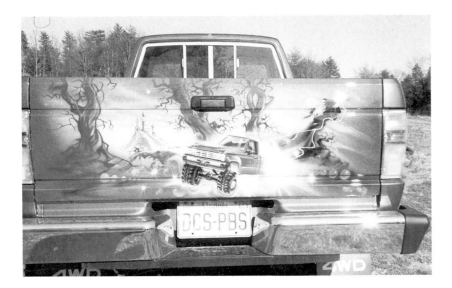

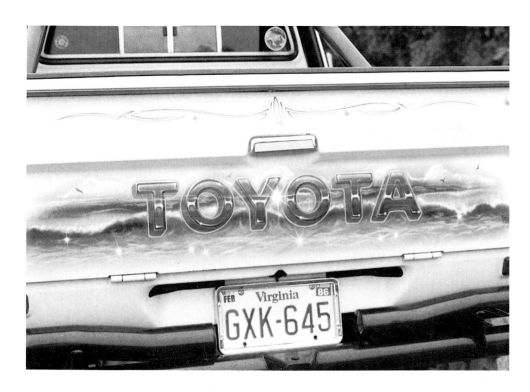

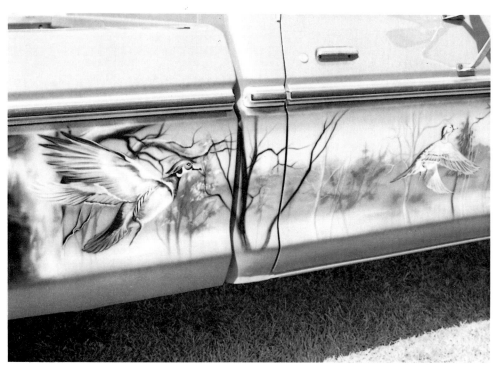

The three photographs on this page show airbrushing on vehicles by Chris Cruz, Florida, USA. All are freehand, using automotive enamels and urethane blends.

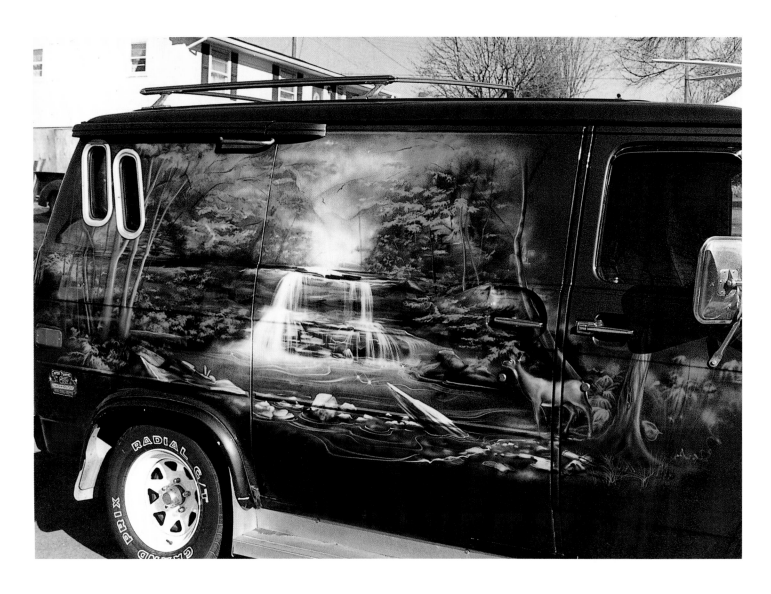

Right; Airbrushing by Chris
Cruz, USA on a 'Wonderland
Video' sign (size 6ft × 16ft)

130

Left and below: airbrush
rendering on a van by Chris
Cruz, USA; freehand, using
auto-enamel paints and a
urethane catalized clear coat
over the entire van to protect
the mural.

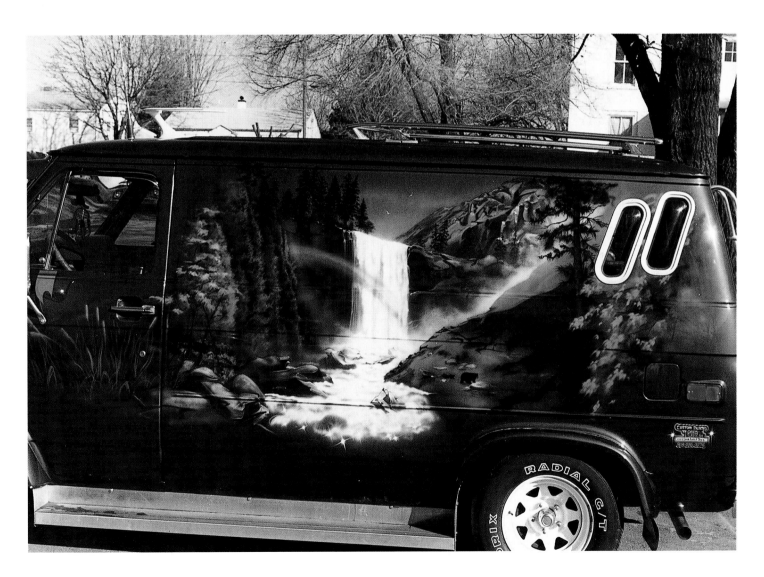

Electronic Airbrushing

In the same way that the airbrush added to the range of techniques available to the artist, so the computer has extended the technology at the illustrator's disposal.

The range of computers known as 'paint system' computers has been designed to incorporate electronically many of the techniques currently used by illustrators and photographers. In the print reproduction industry, for example, electronic airbrushing has now largely replaced manual airbrushing in the retouching of original colour photographs. A transparency can be scanned into a computer, called up on screen and colour added stage by stage. It can be changed quickly and a number of alternative versions of the same transparency produced. Apart from photo-retouching, other effects such as multi-imaging, solarisation and photo-montage can be achieved, using the 'airbrush' facility.

Any material produced on a computer can be 'saved' and stored in its 'memory'. An illustration can be 'saved' at its various stages and called up onto screen for further working. In this way several versions may be produced providing a range of choice for the client.

On a computer, 'airbrush' is an alternative facility to 'sketch' and 'rubber band'. The airbrush produces a dot or textual line in any of the colours available on the colour palette. There are normally a number of pre-set dot sizes available which can be changed at any time during working. Operation is by means of an electronic 'pen' or 'mouse'. The operator presses the pen down onto a tablet and a coloured dot appears on the screen in front of him. By holding the pen in the same position for a few seconds, the dot will progressively expand to produce a circle with solid colour in the centre graduating to light, soft tints at the outer edges, close to the background colour. Thus, the effect obtained is that of real airbrushing. The longer the pen is held in position, the more solid the circle will appear,

Electronic airbrushing cannot, at present, be regarded as a complete equivalent to manual airbrushing. It is not a drawing tool in the conventional sense, its range of effects being confined to pixel retouching, colour graduations and high lighting. I think it can be said with confidence, that the quality and range of imagery that the skilled, imaginative artist can achieve with the manual airbrush is not likely to be superceded by the computer for some considerable time yet.

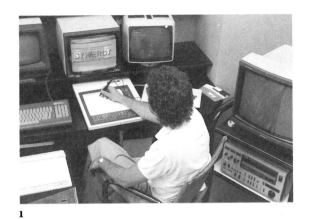

1. An operator at the computer console filling lettering with colour.

2. A typical computer graphics layout. The picture shows a graphics tablet with electronic 'pen', a keyboard and two screens.

3. Floppy disks. These are used for storing the digitised images which have been created on the computer.

4. A colour camera system of the type used for taking 35mm slides of images created on the computer screen.

1

2

3

4

5

6

7

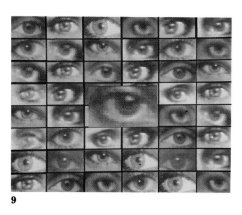

8

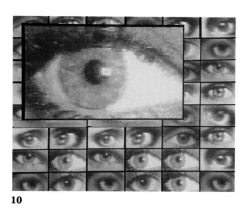

9

10

5, 6, 7. Three versions of the earth's globe showing gradations of tone with alternative colurways.

8, 9, 10. A montage of eyes scanned in via a video camera. One of the eyes has been selected for pixel retouching and enlarged using the computer's zoom facility.

11

12

13

14

11, 12, 13, 14. An example of colour smoothing and blending. The lettering outlines have been drawn on the computer, filled with colours selected from the 'palette' then 'smoothed' to give an airbrushed effect. Random colour changes may be obtained by running through a sequence of colour combinations.

Work by other Artists

This double-page spread shows the airbrushing of a hot air balloon mural (a family of giraffes) entitled 'Tree Grazers', by Daniel Bralski of Ohio, USA. Indelible ink was used on rip-stop nylon (balloon material). The photographs were taken by Daniel Bralski, Sharon Ranch-Bralski, and Howard F. Might.

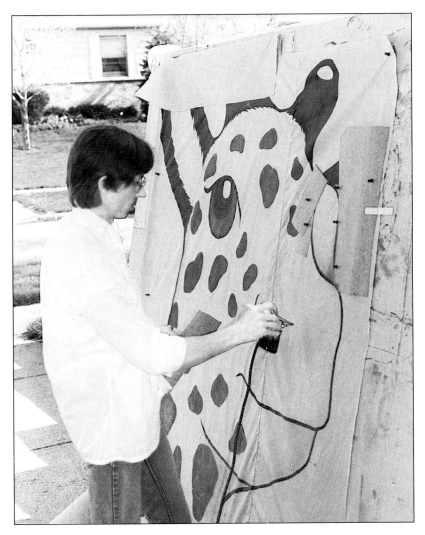

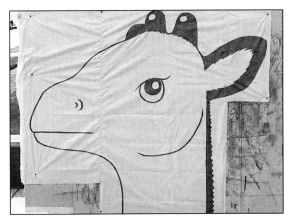

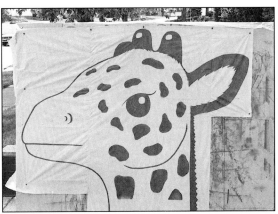

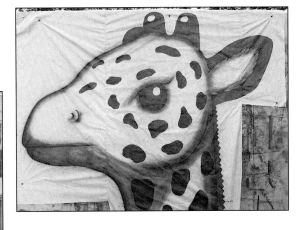

Above: Cover illustration for
Packaging News by Dennis
Hawkins, London.

Above: Book cover for
Weidenfeld & Nicolson by
Dennis Hawkins, London.

Above: Record sleeve for the
Tyla Gang album 'Yachtless'
by Dennis Hawkins, London.

Trace Patterns

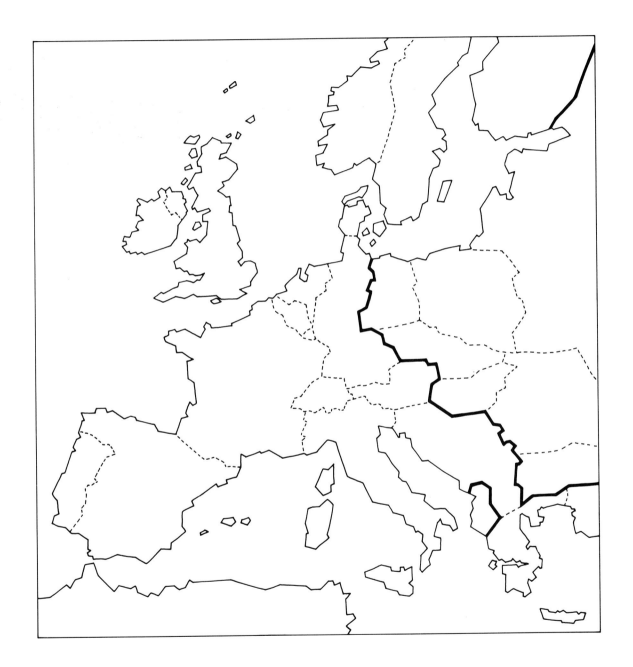

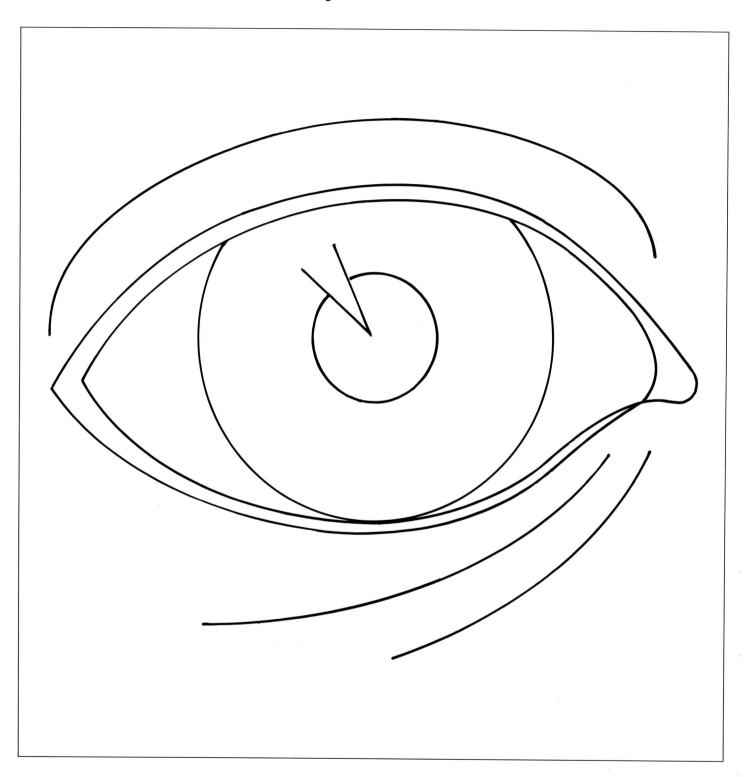

THE COMPLETE
AIRBRUSH
COURSE

Acknowledgments

The DeVilbiss Company Ltd. Paasche Airbrush Company. Badger Airbrush Company. Sindair Graphics Equipment. Winsor & Newton Ltd. Gilchrist Studios

Bob Cotton, Department of Art and Design, Newham Community College. Jonathon Easton, Taylor's Creative Customizing, Croydon

The authors wish to thank John Latimer Smith for his valuable advice and not least his patience in guiding this book through to publication.

We would also like to thank the many other people too numerous to mention who have helped the authors in their task.

Photographic Credits

p7: Francis Kyle Gallery, London; **p8:** Northwoods Craftsman, Wisconsin, USA; **p13:** Imperial War Museum, London; **p78:** Carolina Biological Supply Co., Burlington, North Carolina, USA; **p94:** *bottom*, Northwoods Craftsman, USA; **p96,97:** Northwoods Craftsman, USA.